100 BOOKS

From the Libraries of the National Trust

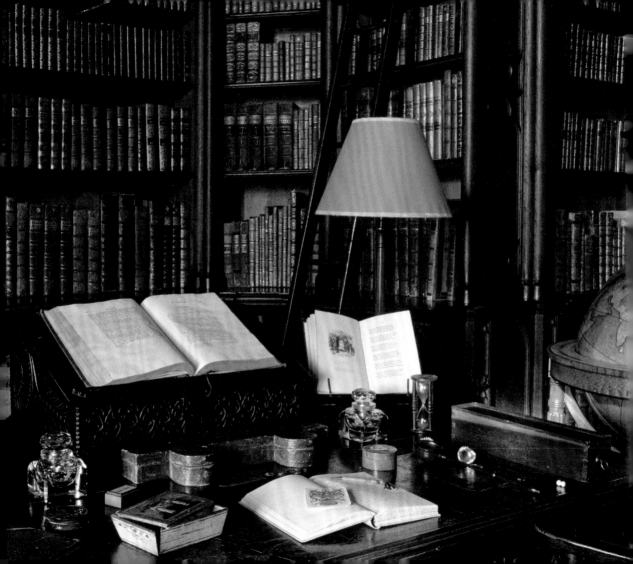

100 BOOKS

From the Libraries of the National Trust

YVONNE LEWIS, TIM PYE
AND NICOLA THWAITE

With entries by Michelle Brown,
Juliet Carey and Rachel Jacobs

 National Trust

Contents

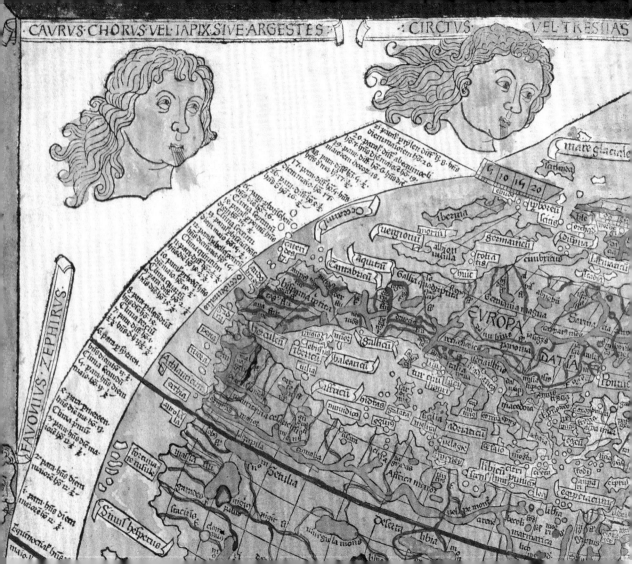

CAVRVS CHORVS VEL IAPIX SIVE ARGESTES · CIRCTVS VEL TRESTIAS

FAVONIVS ZEPHIRVS

mare glaciale

EVROPA

Introduction

The collection of books owned and cared for by the National Trust is among the most important in the world. Far from being a series of spines to decorate library shelves, or rows of books that have been 'bought by the yard', the volumes in the Trust's historic properties constitute a vital resource for understanding the history and patterns of private book ownership and use in the UK and Ireland. Their unique value stems from remaining in the places for which they were acquired, and where they were used, enjoyed and shared across generations. They are intimately connected to readily identifiable places and people, providing us with insights into the ways that books have been used over the centuries, the changing value of texts throughout history, and the mechanisms by which historic collections are built up over time. More than any other type of collection in National Trust properties, libraries can act as archival cornerstones, linking buildings, objects and people.

Generations of users have left behind their own unique marks in the books, and these survive on a scale that is unmatched by any other library collections. This is due to the books being little used in comparison to those held by major research libraries, which have passed through the hands of many readers and researchers over decades, if not centuries. In Trust libraries, vital copy-specific evidence has been preserved that might otherwise have been lost. Original bindings, bookplates and inserts, together with extensive inscriptions and marginalia, provide unparalleled insight into the lives of both books and readers.

These readers form the community that is at the core of each library, and it is evident that many libraries have been shared with, and shaped by, members of the extended family, visiting scholars and people in the local vicinity. Occasionally we find evidence of distinct collections being formed for the use of servants, and in one example – Springhill in Northern Ireland – a lending library established for the

Opposite · Detail from Ptolemy's *Cosmographia*, the oldest atlas in the National Trust's collection (see pages 38–9).

Frontispiece · The Library at Felbrigg Hall, Norfolk, is said to be haunted by the ghost of its book-obsessed former resident William Windham III, who still visits to peruse volumes he didn't have time to read while he was alive.

Pages 4–5 · The Library at Wimpole Hall, Cambridgeshire, was designed by the architect James Gibbs (1682–1754) for Edward Harley, 2nd Earl of Oxford (1689–1741).

use of US soldiers during the Second World War. This sharing of books, an integral and often overlooked aspect of what are usually perceived as quintessentially private collections, is the core purpose of *100 Books from the Libraries of the National Trust*.

The history of books in the National Trust

Although some of the properties featured in this book, such as Anglesey Abbey and Lacock Abbey, have library histories extending back to the Middle Ages, books have not been an ever-present part of the National Trust since its inception in 1895. In its early years the Trust focused on acquisitions of land and ruined or empty buildings, and it was only with the 1909 presentation to the Trust of Coleridge Cottage in Somerset – the first writer's home and the first property acquired for its association with a famous person – that books first entered into the Trust's care (donated by the poet's grandson, Ernest Hartley Coleridge, among others). Further books arrived with the acquisition of Quebec House in 1917 and Treasurer's House in 1930, but it was the period of 1936–40 that saw the National Trust become a significant library organisation. Carlyle's House (1936), Wightwick Manor (1937 – the first house and library to be acquired under the Country Houses Scheme) and Smallhythe Place (1939) provided the Trust with a moderately large and diverse collection of books and manuscripts. However, it was with the acquisition of the Blickling estate in 1940 that the Trust became a major player in the world of rare books and special collections. Blickling's vast library, the majority of which was amassed by the bibliophile Sir Richard Ellys (1682–1742), rivalled the foundation collections of the British Museum Library and those of the great college libraries of Oxford and Cambridge.

The Trust accessioned numerous houses and libraries after the Second World War, and appointed a succession of library advisers, but it was not until the Country House Libraries fundraising campaign of the 1990s that the Trust's position as a library organisation was firmly established. Spearheaded by the Royal Oak Foundation, the campaign raised enough money to endow a full-time librarian, fund the ongoing cataloguing of the books and pay for a programme of conservation. To date, about 75 per cent of the Trust's library collections has been catalogued – over 240,000 titles. This is a vital step to ensure that the collections are known to as many people as possible, and to open them to the research community.

And it is a growing collection. In 2008 the National Trust acquired the *Lyme Missal*.

Right · The magnificent Library at Blickling Hall, Norfolk, holds around 10,000 books (with a further 2,500 elsewhere in the house).

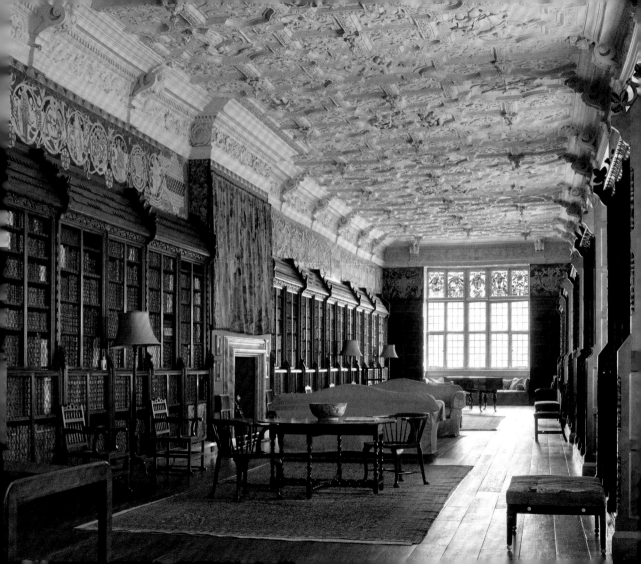

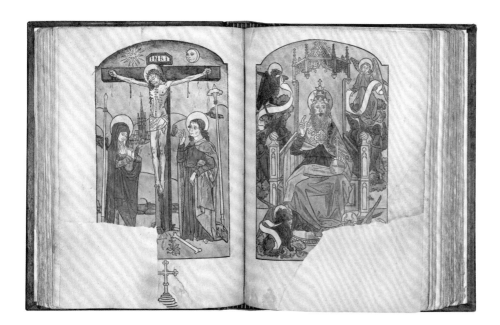

Above · The *Lyme Missal*, a Roman Catholic prayer book of 1487 (NT 3130883), is the only known substantially complete example of this Caxton publication in existence. *Opposite* · The Library at Townend, Cumbria.

Produced by England's first printer, William Caxton, and associated with the Legh family of Lyme Park soon after its 1487 printing, it is arguably the Trust's most important printed book. As recently as 2022, 750 volumes that once formed part of the collection at Dyrham Park were acquired by the Trust and returned to the property's shelves, while a copy of Vita Sackville-West's first publication, *Chatterton* (1909), was acquired for Knole, where the book was written by the 17-year-old author.

The scope of the collection

The size of the National Trust's book collections today is astonishing. Approximately 420,000 objects are spread across some 200 properties in England, Wales and Northern Ireland. It

is no surprise that the majority of these are held in country house libraries. These are the intellectual centres of the nation's great ancestral homes. Their finely crafted interiors clearly show the importance placed on the display and arrangement of books, from the small but exquisite 17th-century library at Ham House to the 20th-century grandeur of the library at Anglesey Abbey. They are the rooms in which legends have been preserved, stories have been shared and creative inspiration has struck.

But, as has been indicated by some of the properties mentioned, the Trust's libraries are far more than an assortment of aristocratic book repositories. There is great variety and breadth in the places where books and other reading material are found, such as the farmhouse libraries at Townend and Ty'n-y-Coed Uchaf; the Styal Village Club Library used by workers at Quarry Bank Mill; the suburban and city-centre domestic libraries at Mr Straw's House and 575 Wandsworth Road; and the printing

history collections at Cherryburn and Gray's Printing Press. There are also those books from the homes of famous writers, which provide a fascinating insight into the creative processes and literary networks of individuals such as Rudyard Kipling, Agatha Christie, George Bernard Shaw and Vita Sackville-West.

The variety of properties is matched by the wide range of material that falls within the scope of the Trust's libraries. Items range in date from the early 8th century right through to the 21st, and include books and manuscripts produced in all seven continents (five of which are represented in this book). And while the vast majority of the collection is made up of bound printed books, other categories of items – some of them unusual – can be found across the Trust, including medieval manuscripts, scrapbooks, maps, braille books, posters, leaflets, volumes of Japanese prints, music scores and recordings, palm-leaf manuscripts, globes and books for children.

Selecting 100 books

In the 114-year history of the Trust's libraries, this is only the third publication dedicated to presenting a selection of the organisation's books to the general public. The previous two books were exhibition catalogues – one to accompany an exhibition hosted by the National Book League in 1958; the other, *Treasures*

Above • Gray's Printing Press at Strabane, County Tyrone (see page 197).
Opposite • Crime writer Dame Agatha Christie in her library at Greenway, Devon, in 1946.

from the Libraries of National Trust Country Houses, was the guide to a 1999 exhibition in New York City (mounted in large part to celebrate the successful Royal Oak Foundation fundraising campaign). Both books evidence the National Trust's libraries as repositories

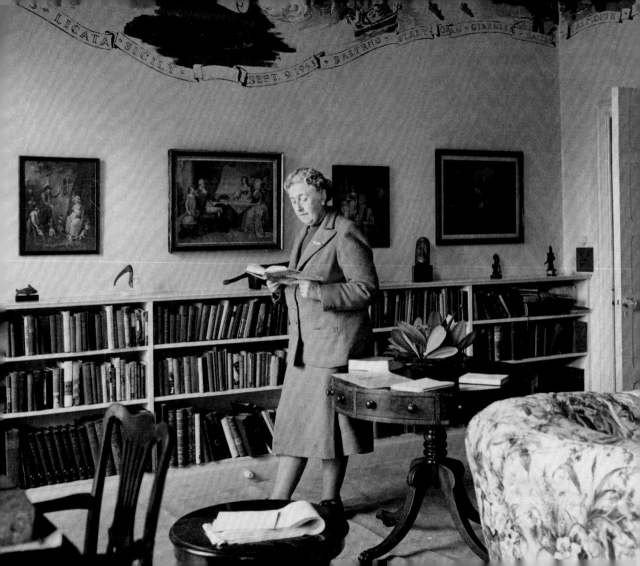

of great bibliographical treasures and major achievements in the history of the written word. The introduction to the 1958 catalogue describes its selection as representative of the 'rare and important books' on the shelves of the Trust's libraries, which can be found 'normally standing … among compositions very much less interesting'.

In the 65 years since these words were written, the understanding of what is in the Trust's libraries has increased exponentially, and their unique significance has come to the fore. The collection's true value is not solely in the examples of 'great' books that can be found on the shelves – although there are certainly many of them – but in the histories of people and places that even the most ordinary of books can reveal.

Needless to say, selecting 100 books from a collection as vast as the Trust's is challenging, and such a selection can never be comprehensive. But those presented in chronological order over the following pages have been chosen to showcase the strength and variety of the collections. Some of them are undoubtedly rare and magnificent treasures, others are what might be considered minor items, but they all have interesting stories to tell about their creation, and compelling accounts of ownership and use by men, women and children of all classes. They illustrate the national and global connections found within Trust properties, sometimes highlighting uncomfortable histories. They shed light on and celebrate personal relationships that throughout history have had to be hidden. They are visually compelling and sometimes surprising. Above all, they reveal the extraordinary breadth of the collections and reflect the continued relevance of the Trust's libraries in the 21st century.

It is hoped that this book will lead readers to be even more curious about the rows and rows of books in the National Trust's libraries, and the invaluable narratives held within each volume. As the cataloguing of the collection continues apace, and further intriguing stories are revealed, the Trust will carry on displaying its books on site, online and in publications, ensuring that these vitally important and fascinating objects are available for everyone, for ever. The National Trust, its supporters and visitors are just the latest members of the communities at the heart of these captivating library collections.

Tim Pye
National Curator (Libraries),
National Trust

Opposite · Vita Sackville-West photographed by Norman Parkinson in the Long Library at Sissinghurst, Kent, in 1949. *Overleaf* · The Library at Ham House, Surrey, constructed in 1672–4, with wheeled carved oak steps of *c.*1740.

100 BOOKS

That's a wrap

This rare surviving leaf of one of the West's most famous manuscripts was found in 1984, wrapped around documents from the Bankes estate in Dorset. It had been part of one of three massive single-volume Bibles, known as the Ceolfrith Bibles, named after the abbot of the twin monastery of Monkwearmouth–Jarrow in Anglo-Saxon Northumbria. Bede (c.672–735), a monk there at the time, served as one of the scribes.

Bede reported that Ceolfrith (642–716) ordered three volumes to be written – one for each of the twin monasteries, the third as a gift for the pope. Ceolfrith died en route to Rome in 716, but his companions travelled on and presented the book to the pope as an ambassador for the newly established English Church and people, proving to one of the cradles of early Christianity that a new focus of learning and faith was now to be found in these islands on the edge of the known world. The pope's copy survives in the Medici library in Florence and is known as the *Codex Amiatinus*. It was recognised during the 16th century as the best surviving version of the Latin edition, or Vulgate Bible, made by St Jerome in 4th-century Bethlehem.

With its painterly classical images, elegant uncial script and fine text, this scholarly copy was originally thought to be Italo-Byzantine, but in the 1880s it was finally credited as English work. Few fragments of the other two Bibles survived the centuries. MB

Kingston Lacy, Dorset · Bible, Ecclesiasticus 25:10–37:2 · *Monkwearmouth-Jarrow, Northumbria · Early 8th century, pre-AD716 · 42 x 33cm · Folio · Library of Sir Francis Willoughby of Wollaton (1547–96); disbound and used to wrap estate records; included in documents transferred to the Bankes family in 1635 · NT 3174715*

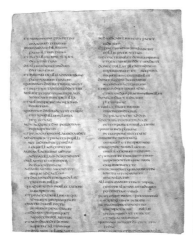

ET NON MINUAS PRIMITIAS
MANUUM TUARUM
IN OMNI DATO HILAREM
FAC UULTUM TUUM
ET IN EXULTATIONE SCĪFICA
DECIMAS TUAS
DA ALTISSIMO SECUNDUM
DATUM EIUS
ET IN BONO OCULO ADINUENTIONẼ
FAC MANUUM TUARUM
QUONIAM DNS RETRIBUENS EST
ET SEPTIES TANTO REDDET TIBI
NOLI OFFERRE MUNERA PRAUA

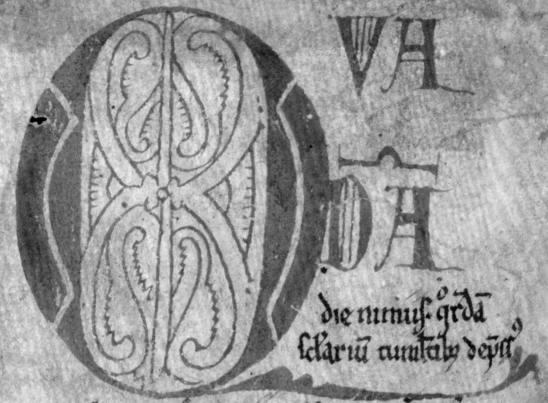

VA

DA

die nimus̄ q̄rdā
sclariū cumtaly depꝭ

quib; in eius negocus pluſq; cog. in solue

ꝗ quod nos certū est n̄ debere: secretū locū
pecū amuū merꝛ·ubi cīnc q̄ de mea
in occupatōe displicebat se patenū ostēdēt

Both practical and miraculous

One of the National Trust's oldest books, this 12th-century manuscript was written in several stages. There are two parts to the text, which is written in Latin and Middle English. The first part contains two books: Pope Gregory's *Dialogues*, a collection of miracle stories originally written in 6th-century Italy, but copied many times since; and the Litany of the Saints, a set of formal Catholic prayers used throughout the year. The list of saints' names was personalised to include the Saxon saints Osyth, Erkenwald and Mellitus. These names indicate that the text was probably written in a monastery in the south-east of England.

The second part of the manuscript, written in the early 13th century, also contains two books: the Rule of St Benedict and the Rule of St Augustine. Designed as practical guides for religious houses, these rules encouraged obedience, humility, contemplation and a simpler way of living. A 14th-century owner of the manuscript added a contents list to help readers navigate the text. YL

Blickling Hall, Norfolk · Dialogues of Saint Gregory · *Pope Gregory I (c.540–604) · Copied in south-east England · 12th and 13th centuries · 26.5 x 18cm · Folio · 19th-century rebinding of parchment over wooden boards · Library of Sir Richard Ellys of Nocton (1682–1742) · NT 3130718 · ‡1940*

Rhyming Bible

Although a small and now rather scruffy-looking book, this copy of *Aurora* – a verse abridgement of the Bible – is contained within the National Trust's oldest binding. Both text and binding were made in the first quarter of the 13th century and have remained together ever since. Its author, Petrus Riga (1140–1209), was a canon of Reims Cathedral and a well-known French poet. His book proved immensely popular, as its simplified and rhyming text made the Bible easier to recall, especially for preachers.

The Coughton Court copy of *Aurora* was written around 1210. Very soon afterwards, texts and sermons on the saving of souls were added, and they were all bound together.

The *Aurora* is one of the religious manuscripts owned by the Throckmorton family. As Catholic recusants in a Protestant country, their faith was important to them. The signature of Sir Robert, the 3rd Baronet, shows that the book was in his library at Weston by 1684. It was later moved to Coughton Court by one of his successors. YL

Coughton Court, Warwickshire · Aurora · *Petrus Riga · Northern France · 1210? · 24.4 x 17.5cm · 13th-century pink-stained alum-tawed goatskin binding over oak boards · Signature of Sir Robert Throckmorton, 3rd Baronet (1662–1720) and bookplate of his son Sir Robert Throckmorton, 4th Baronet (1702–91) · NT 3081866*

psallentib; inmedio iuuencu
larum tympanistriarum.
In ecclesiis benedicite deo: dñs
de fontibus israhel.
Ibi beniamin adolescentulus: i
mentis excessu.
Principes iuda duces eoz: prin
cipes zabulon principes nephtal.
Manda deus uirtuti tue: confir
ma deus quod operatus es i nob.
A templo tuo in iherlm: tibi of
ferent reges munera.
Increpa feras arundinis con
gregatio taurorum in uaccis p
pulorum: ut excludant eos qui
probati sunt argento.
Dissipa gentes que bella uol?
nt: uenient legati ex egypto eth
opia preueniet manus ei? deo.
Regna terre cantate deo: psal?

ite domino:
Psallite deo qui ascendit sup celu
celi ad orientem.
Ecce dabit uoci sue uocem uirtutis:
date gloriam deo sup irahl' magni
ficentia eius: z uirtus ei? in nubib;
Mirabilis ds in sctis suis: ds ihr'l
ipse dabit uirtutem z fortitudi
nem plebi sue: benedictus ds

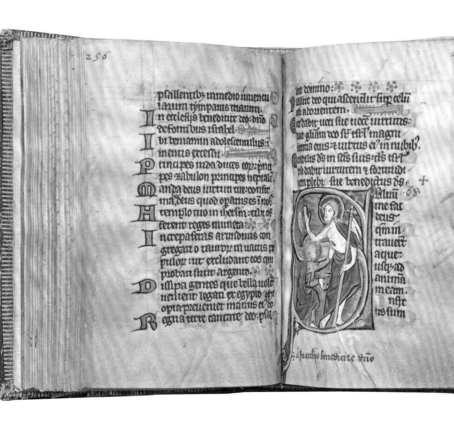

Saluu
me fac
deus
qm in
trauerut
aque
usq; ad
animam
meam.

Infi
xus sum

hoc psmo benedicite dño

Psalms and salvation

Psalters – consisting of the biblical psalms, prayers and perhaps a calendar marking the saints' feast days of the year – underpinned both public and private devotion during the Middle Ages. The psalter shown here includes images of saints, such as Doubting Thomas (opposite), and St Margaret, patron of pregnant women, which may indicate its intended readership.

Margaret Hill, née Wyts or Wiits (d.1615), was the daughter of John Wiits, a merchant of Ghent. The Wyts family fled Antwerp during the Wars of Religion (1562–98), eventually reaching England. This psalter may have travelled with them. In England, Margaret married prominent English Protestant preacher Robert Hill (d.1623). Dying in childbirth aged 39, Margaret left her possessions to Robert. He kept the psalter, signing and paginating it. Deep personal connections may explain Robert using an older medieval book to study the Psalms, which remained a mainstay of Protestant prayers. MB

Arlington Court and the National Trust Carriage Museum, Devon · Psalter (with Roman division of the Psalms), with Office of the dead (Rome Use) · *Southern Netherlands · c.1275–1300? · 11.5 x 8.5cm · 17th-century English leather binding, gilt tooling · Margaret Wyts of Ghent and her husband Robert Hill · NT 3083260 · Given to the National Trust for Arlington Court*

فاذا تهايـوا للكر يتقدم الصف الذى تدام ويبقى الذى خلفه مسرته ولـلحاجز في
كاهر ويترتبه تواصله النجمه ويتووقون المعزيص الرباح الجمل ثان الجحرى يفعلوا ا
يمينا وشمالا وكل صعب في منازله ولا يبارو رافعوا الصابه ثم بنافذوا والكل وليه الزى قال

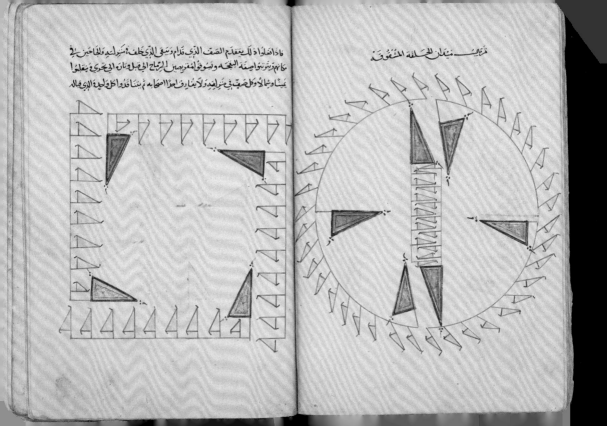

A remarkable paper item

Between 1815 and 1819, William John Bankes (1786–1855) travelled throughout Egypt and the wider Levant, visiting historical sites and recording his observations in thousands of meticulous drawings. This period witnessed a great number of ancient Egyptian treasures being removed to Europe, and while Bankes was not as voracious a collector of artefacts as some of his contemporaries, he did bring antiquities back to his home, Kingston Lacy, including a 9-metre-high obelisk, numerous papyri and two Islamic manuscripts.

The most important of the manuscripts is this volume of treatises on war and cavalry written at the beginning of the 14th century during the period of the Mamluk sultanate in Egypt. Beautifully decorated in red, blue and gold, its most eye-catching elements are the stylised diagrams of cavalry formations, with triangles representing horses and riders (those in gold corresponding to commanding officers). It is an outstanding example of early Mamluk literature and design, and is the earliest item on paper in the National Trust's collections (all earlier Western manuscripts are written on parchment). TP

Kingston Lacy, Dorset · Collection of Mamluk Treatises · *Egypt · c.1308 · 27 x 19cm · Late 18th-century Egyptian binding of card boards and red leather spine · NT 3242980*

A traveller's tales

Geoffrey Chaucer (c.1340–1400) was one of the greatest poets of the Middle Ages. From a prosperous merchant family in London, he spent his life serving royalty in several capacities, thus becoming well connected. He travelled extensively in Italy and France, and became familiar with the works of Dante, Petrarch and Boccaccio, which influenced his own writing.

The Canterbury Tales were written in Middle English during the last decade of Chaucer's life. They are based around a group of pilgrims who meet while journeying to the tomb of St Thomas Becket in Canterbury, and each pilgrim tells a tale en route (Chaucer originally planned that each pilgrim would tell two tales). His characters – vivid, full of humour and tragedy – are still recognisable today. Sadly, the work was incomplete when he died.

The Petworth copy is one of over 80 surviving manuscripts made for aristocratic patrons. The illuminated coat of arms on the final leaf (opposite) indicates that it was owned by the Percy family from 1477. YL

Petworth, Sussex · The Canterbury Tales · *Geoffrey Chaucer* · *England* · *1420–40* · *35 x 26cm* · *Folio* · *15th-century binding, wooden boards with metal bosses and corner pieces, re-covered in red velvet 1859–63* · *Coat of arms of Henry Percy, 4th Earl of Northumberland (c.1449–89)* · *NT 3242251* · *‡ 1956*

Here endeth ye boke of ye talys of Cantburye compyled by Geffray Chaucer on whdos soule Ihū crist haue mercy. Amen

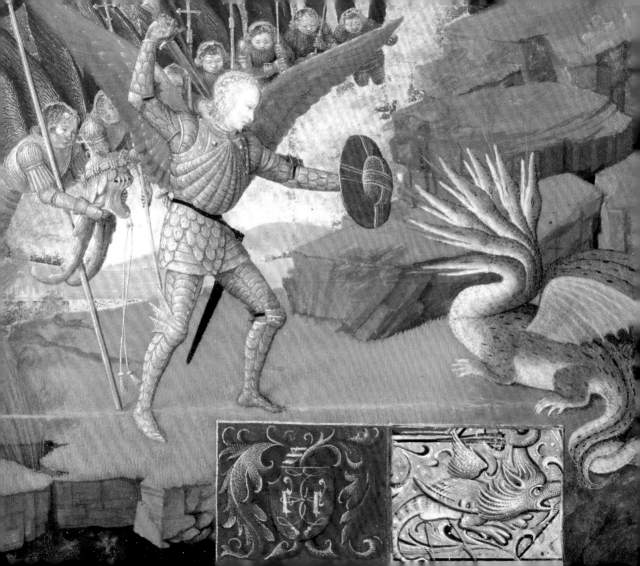

A forgotten master

Jean Fouquet (c.1420–c.1481) was France's most important 15th-century artist. He painted for the French kings Charles VII (1403–61) and Louis XI (1423–83) and their courtiers. Most French works of art from this period survive as manuscript miniatures. Celebrated within his lifetime and for around 50 years after his death, Fouquet was almost forgotten by 1600.

One of Fouquet's most important clients was Étienne Chevalier (c.1420–c.1480), the Treasurer of France. In the 1450s, Fouquet produced for him a book of hours, known as *The Chevalier Hours*. It was dismembered during the 18th century and all that survives of it are the 46 full-page miniatures, of which this is one.

The main image on the front of this leaf (the text, above right, is on the reverse) shows St Michael battling a seven-headed dragon. The results of the battle are shown below. Within each of the full-page illustrations Fouquet included his own initials and the cipher of his patron. YL

Upton House, Warwickshire · St Michael slaying the dragon (from The Hours of Étienne Chevalier) · *Jean Fouquet · 1452 · 15.6 x 11.7cm (fragment) · Gouache on vellum · NT 446781*

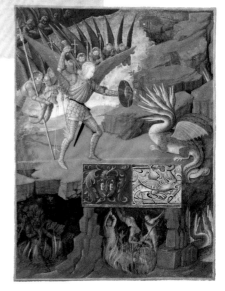

Who rules the kingdoms of earth?

William of Ockham (c.1287–1347) was one of the great medieval philosophers. He joined the London Greyfriars, a Franciscan order, at an early age and went on to write extensively and sometimes daringly on natural philosophy, logic and theology. He was called before the papal court at Avignon to defend some of his theories. While there, he was caught up in the dispute between the Franciscans and Pope John XXII (1249–1334) over the idea of apostolic poverty. For their views, Ockham and others were forced to flee into exile, first in Italy, then in Germany.

Ockham's *Summaria, or The Work of Ninety Days*, was written in 1332–4. This copy bears the distinctive handwritten number '282', which identifies it as the 'Epitome Occham' listed in the 1542 inventory of King Henry VIII's library. The characteristic wavy lines and marginal notes show it to have been consulted by Henry's agents in the matter of his divorce from Catherine of Aragon (1485–1536). Passages relating to a monarch's power being superior to the pope's have been marked. YL

Lanhydrock House, Cornwall · Summaria seu Epitomata CXXIII Capitulorum Operis XC Dierum · *William of Ockham* · Lyon, France · 1495 · 28.3 x 20cm · Folio · Late 15th- or early 16th-century sheep binding over wooden boards · Hannibal Gamon (c.1582–c.1651) · NT 3069171

No expense spared

The National Trust's finest manuscript was made for wealthy book lover Borso d'Este, Duke of Ferrara, Modena and Reggio (1413–71), in 1452–3. Part of the Renaissance revival of interest in classical texts, *Lives of the Caesars* by Suetonius (*c*.69–*c*.122) was extremely popular. The original was probably written during Emperor Hadrian's reign (AD117–138), when Suetonius, a court administrator, had access to the imperial archives, as well as to contemporary gossip.

The duke spared no expense on what was possibly his first manuscript commission. Court scribe John of Mainz (dates unknown) and court book painter Marco dell'Avogaro (active 1449–76) worked together on this elaborately decorated volume. On the opening page of each 'Life' is an antique-style medallion profile of the Roman emperor in question, with highly decorated initials and ornate white vine scrolls.

Sir Richard Ellys (1682–1742) probably bought this book during his travels in the Low Countries as a young man. It was then passed down with his library to his distant cousins the Hobarts of Blickling Hall. YL

Blickling Hall, Norfolk · De Vita Caesarum · *Suetonius · Ferrara?, Italy · c.1452 · 31 x 22cm · Folio · 17th-century calf binding over boards with gilt tooling · Library of Sir Richard Ellys of Nocton · NT 3130728 · ‡ 1940*

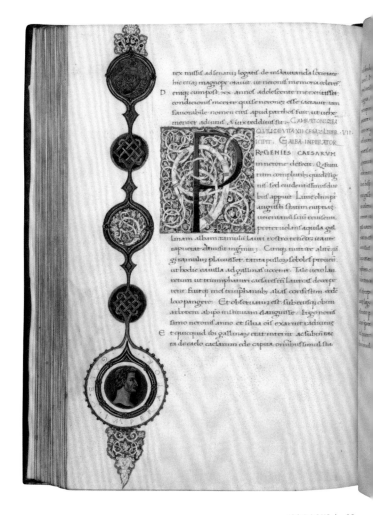

Proof of purchase

A cartulary is a medieval bound book or roll written on vellum and containing copies of documents relating to land ownership. The *Tropenell Cartulary* is a rare surviving secular example. Created or commissioned by Thomas Tropenell (*c*.1405–88), builder of Great Chalfield Manor house, it contains copies of documents dating from the 13th to 15th centuries.

Written over two decades, this volume documents Tropenell's steady acquisition of manors and parcels of land in Wiltshire, including some that had previously belonged to the Percys, Earls of Northumberland (Thomas Tropenell's ancestors were a minor branch of the Percy family). The cartulary also includes various documents relating to the Percys and to the history of Wiltshire. Arranged by estate, it contains a section that describes Great Chalfield, while the section describing Old and New Sarum includes details of the building of Salisbury Cathedral.

When the estates of Great Chalfield and Monks were divided in 1599, the cartulary went with the Monks estate. It then passed through the hands of the families who owned that estate until the mid-19th century. When the Harman family sold the Monks estate in 1852, they retained the cartulary. In the early 1900s it went to auction twice, being bought on the second occasion by R.F. Fuller (1875–1955), who gave it to the National Trust in 1943. YL

Great Chalfield, Wiltshire · Tropenell Cartulary · *Thomas Tropenell · Great Chalfield · 1464–88 · 35.5 x 28cm · Folio · Later rebound with vellum and tawed leather over boards · NT 3069461 · Given by R.F. Fuller in 1943*

Doughter to S^r Phylyppe Dynzon of Devonshire Knyght whiche bare these armes

A feld of Gewles in the feld of Silver whiche S^r Dyers and Beatrice had issue to gedirs S^r Dyers and Beatrice afterwards whan Dyers was decessed the sayd S^r William entred into the sayd manor of Chittelhampton And vnto the sayd S^r ... whiche before reharsed And therof was seised in his Demayn as ... And toke vnto wyff Agnays Doughter to S^r John Stourge Knyght ... destrofyd in Wiltshire whiche lord S^r Thomas Hungerford ... the sayd S^r Agnays bare these armes

... Rampanttes of Gewles in ... in Dimo regni Regis Edward ... ory Knyght made ... of the manor of ... of ... yere ... tymes ... Anno regni ... thereof yerely xxxvj li. ... The sayd S^r ... issue many children that is to say S^r Harry Darcy Knyght John S^r ... S^r Isabell and Katryne / The sayd S^r John S^r ... and Anthone issue S^r the sayd S^r William and Agnays ... S^r Kathryn were maried to Walter Trevanett second son to S^r Osbert Trevanett and ... Trevanett Knyghtes before the tyme of mynd lordes and patrons of ... Wiltshire With the Church of the same and of lordes ... as in a transcript of dedes ... Trevanett Squyer Anno quarto Edward quarto of all his lordes and ... playnly makith mencion Whiche bare these armes

... a Bende of Silver and vitailes powdered With compeny ... of the same ... the sayd Walter and Katryn had ... a son Phelyppe and a Doughter Sabella Whiche Sabella ... these sayd certeyn lordes and rents vnto the hows of ... and was Wont issue William toke to wyff Isabell Doughter ... S^r ... of Cornwall Attalias ... by moche ... Wiltshire whiche ... bare

A feld of gold a Bende of Gewles ... to gedirs ij sones Roger Trevanett of Chittelhampton by the sea John Trevanett of Newton Knyght toke to wyff Cristian ... lord of Half Sumer Annexe to Newton has ... these armes ... decessed Anno

... Gewles in these Rampanttes of Silver powdered With Ermyne armed Gewles Knyght ... and Anno ... and had issue to gedirs a son John Trevanett and many mo children whiche had Wont issue ... the sayd John toke to wyff Agnays Doughter to James the lord of London whiche bare these armes

... of Silver iij torches of Sable ... had issue to gedirs Thomas Trevanett ...

A feld of Silver iij boores hedes of Sable ... S^r harry Trevanett whiche toke to wyff Roche a yonger broder to S^r John Roche Roche of Bromston whiche bare these armes ...

... of Silver iij torches of Silver a border of ... the same ... harry to this Christe had issue to gedirs Thomas Trevanett Squyer lord of the sayd Agnes Chittelhampton whiche had the koveray of ij kynges that is to say kyng harry the vjxt and kyng Edward the iiijth whiche Thomas toke to wyff Margarete Doughter to William Leudelowe lord of Hitte Deverell broder to ... Knyght of England that is to say kyng harry the vjth the iiijth and the vjth whiche bareth these armes

A feld of Silver a Cheverond of Sable in ... same Sable whiche is buried in Saynt Thomas church vnder a Dyable tombe atte the ende of the hygh ... therof The sea of the whiche the sayd William Leudelowe hath be ... seised and peynted And satte With ... of armes of hymself his wyff ... the children The sayd Thomas Trevanett Margarete his wyff hadd issue to gedirs ij sones humfrey and Cristofer and ij doughters Anne and Marye all alde atte making of this boke the sayd John Trevanett of Chittelhampton hath issue John Trevanett and John hath issue John and John hath issue Agnays maried to Thomas Yea of Newton whiche Yea had issue to gedirs John Yea other wyse namyng hym self John Trevanett and harry a yonger son alde atte making of ys boke The sayd S^r William and Agnays Dyers after whos decesse the sayd second S^r harry son of the sayd S^r William and Agnays entred vnto the sayd manor of Chittelhampton ... vnto the sayd other manors afore reharsed as son and heyre vnto the same S^r William and therof was seised in his Demayn as in fee And toke to wyff Eva Doughter to S^r John ... lord of Chittelhampton ... in Wiltshire whiche bare these armes

A feld of Asure iiij Gewles Cheke ... whiche harry and Eva his wyff had issue to gedirs Roger S^r ... and S^r William Knyghtes and Isabell The sayd S^r Walter William and Isabell Dyers Withoute issue / The sayd S^r harry and Eva ...

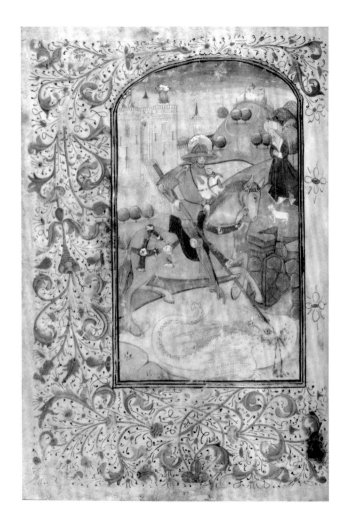

A shared book of hours

Books of hours are lavishly decorated manuscripts, first produced in the 13th century to satisfy the growing demand among lay people to participate in the daily devotions usually undertaken by monks, nuns and priests. The thriving scribal industry in Flanders – specifically Bruges in this example – responded to this demand by producing many devotional manuscripts, some of which include English text, an indication that they were intended for export to Britain. The copy at Powis Castle also includes English iconography relating to Thomas Becket (1120?–70) and St Michael's Mount in Cornwall.

The Powis Hours was originally produced for Eleanor Percy (*c.*1474–1530) to celebrate her marriage to the 3rd Duke of Buckingham (1478–1521). Probably concealed during the Reformation, as none of the imagery or text has been defaced, the book was passed down to another Eleanor Percy (*c.*1582–1650), who brought it to Powis Castle when she married the 1st Baron Powis (1574–1656). This strong female provenance, and its status as the only medieval manuscript in a Welsh National Trust library, make this an incredibly significant book. TP

Powis Castle, Powys · The Powis Hours · *Bruges* · *c.1480–90* · *19.8 x 15.8cm* · *Octavo* · *19th-century black morocco binding* · *NT 1181034*

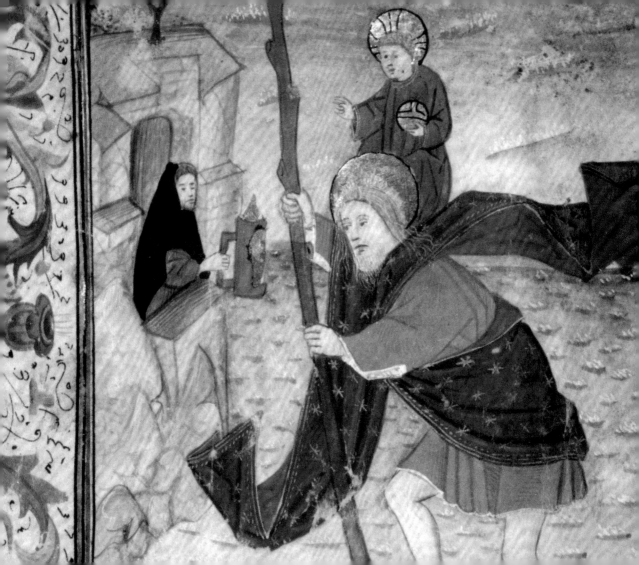

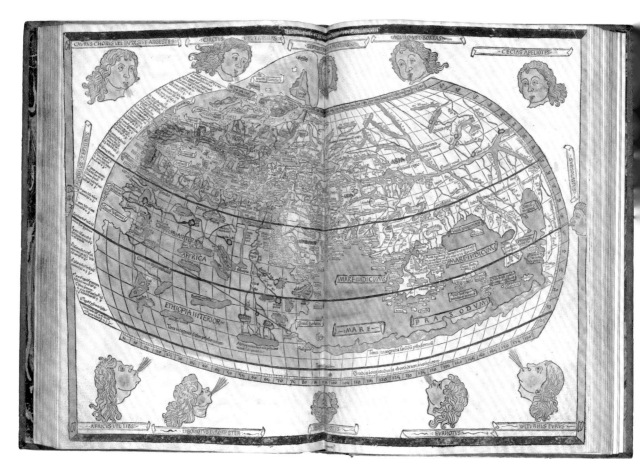

The world in a book

Often known as the 'Ulm Ptolemy', this is the National Trust's oldest atlas. Ptolemy (AD100–168) wrote his original text in Greek at Alexandria and it is arguably the most important work to have survived from antiquity. While it may originally have had maps, none was present when the book was rediscovered by Renaissance scholars.

After translation into Latin, three editions, with copperplate maps, were produced in Italy in 1475, 1477 and 1478. The maps were reconstituted from Ptolemy's written descriptions and updated by cartographers with information from recent explorers' discoveries. This 1482 Ulm edition, with woodcut maps, was the first to be printed north of the Alps. Produced before Columbus reached the Bahamas in 1492, this was the most up-to-date atlas in print before the Americas were added.

The printer Lienhart Holle (active 1478–84) produced a limited edition of 300 copies, with fine hand-coloured maps. Such an expensive book sold very slowly, so a few years after its publication, the printer went out of business. It must have continued to sell and to have been a treasured book, since 137 known copies survive in libraries today. YL

Blickling Hall, Norfolk · *Cosmographia* · *Claudius Ptolemy · Ulm, Germany · 1482 · 43 x 35cm · Folio · 18th-century plain calf binding · Library of Sir Richard Ellys of Nocton (1682–1742) · NT 3130689 · ‡ 1940*

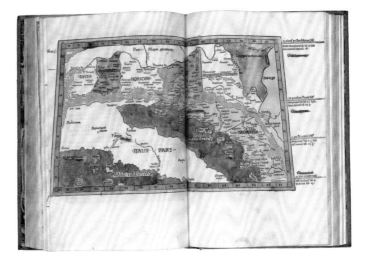

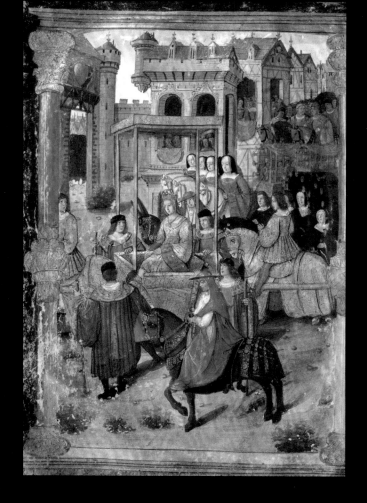

Pomp and ceremony

This unique manuscript describes and illustrates the coronation of Anne of Brittany (1477–1514), her entry into Paris and her coronation banquet in 1504. This was her second time as queen consort of France. As Duchess of Brittany, she married King Charles VIII of France (1470–98) in 1491, and after his death married his successor Louis XII (1462–1515) in 1499. This second marriage was a term of her first marriage contract to secure the union between the Duchy of Brittany and the French crown. Anne safeguarded Brittany's autonomy and promoted its heritage. In France she was celebrated as a symbol of peace and unity.

On the last page of the manuscript the author addresses an acrostic poem to the queen – the first letter of each line spelling out his name. The book was probably produced under the supervision of the poet André de La Vigne (c.1470–1526), who gave it to his queen. She was a great patron of writers, with a library of treasures including commissions and presentation copies recording historic events. RJ

Waddesdon Manor, Buckinghamshire · The Coronation of Anne of Brittany · *Text by André de La Vigne, illuminations by the Master of the Chronique Scandaleuse · Paris · c.1504 · 20.4 x 15.4cm · 16th-century red morocco binding with gilt tooling · Waddesdon 917*

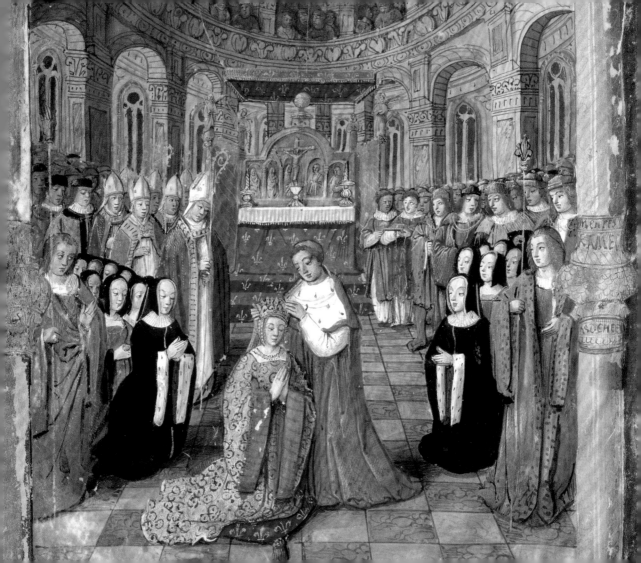

Vsus Ora pro nobis beata anna R̄.
Vt digni efficiamur promissioib;
chūsti. ℟. Oratio.

Eus qui beate anne tanta
grām donare dignatus
es: q̄ beatissimam matrem tua
m suo gloriosissimo vtero porta
re meruit: da nobis per intercess
sione matris & filie tue propicia
tiois abundantia vt quarum co
memoratioe pio amore amplec
timur & earu precibus ad celeste
patriam peruenire valeamus.
Per dominum.
De sca maria. Magdalena. ant.

Maria ergo
vnxit pedes ie
su & extersit
capillis suis &
domus imple
ta est ex odore
vnguenti.
Dimissa sunt
ei peccata multa.

℟. Quonia dilexit multum. Oro.
Argue nobis clemetissime
pater: q̄ sicut beata maria
magdalena dīnm n̄rm supra
diligendo suoru obtinuit venia
peccaminu ita nobis apud tua
miam impetret beatitudinem.
Per dn̄m. De sancta katheria.

Virgo sancta
katherina gre
cie gemma ve
alexandrina
costi regis erat
filia. V. Diffu
sa est gra inla
bus tuis. R. m
Propterea bene
dixit te deus
in eternum. Oratio:

Eus qui dedisti legem moy
si in summitate montis syuay &
in eodem loco corpus beate kathe
rine virginis & martyris tue p
sanctos angelos tuos mirabiliter

Treasures from Spain

The businessman William Gibbs (1790–1875) spent many years in Spain as a young man. He returned in the 1850s, bringing home furniture and paintings to fill his recently acquired house at Tyntes Place, later renamed Tyntesfield. Over the next two decades he bought regularly through London book dealers, filling his newly built library. With great profits coming from the family firm's guano contracts, Gibbs could afford to fill his house with the finest objects.

They included this Book of Hours, which comes from the library of Manuel John Johnson (1805–59), President of the Royal Astronomical Society (1857–8). Johnson's library was sold at Sotheby's in 1862, where it was bought by the London dealer James Toovey, who later sold it on to the Gibbs family. Sometime after the sale, the 'old Spanish red morocco' binding was replaced with the highly decorative religious work of art it bears today.

The scribe and the illustrators of the book were French. The inclusion of prayers to St James, the patron saint of Spain, could suggest that the first owner was Spanish. YL

Tyntesfield, North Somerset · Book of Hours · *Spanish and Latin* · *For use in the Roman Catholic Church* · *Tours?, France* · *c.1515* · *19.5 x 12.5cm* · *19th-century white metal cover added after 1862* · *NT 3073612*

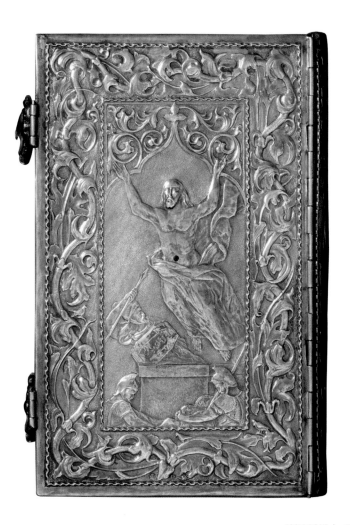

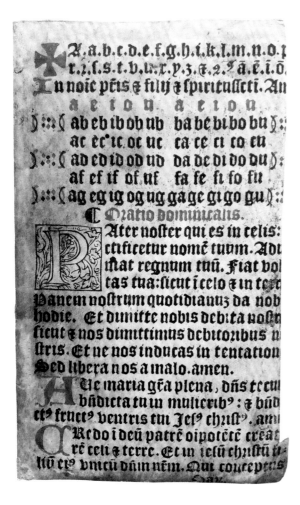

Early alphabet

Alphabet books, sometimes known as primers, were designed for teaching young children. The unique example shown here is the earliest-known ABC printed in England. Books of this kind are found in a number of different formats. The Lanhydrock ABC is an example of an individual tract or short essay. Only eight pages long, it contains the alphabet, followed by some basic religious material necessary for a child to recite in church and at home. This includes the Paternoster, Ave Maria and Credo, as well as various graces and prayers to be said at mealtimes. Small in size and length, it is an ideal book for children.

Many of the oldest books in the library at Lanhydrock were collected before 1680 by John Robartes (1606–85) and Hannibal Gamon (c.1582–c.1651). The books were moved into the Long Gallery in the early 1800s. As a result of fire in 1881 (opposite), much of the house was destroyed and many books were damaged. The family employed W.H. Allnutt, Assistant Keeper at the Bodleian Library, to sort and catalogue the library after the fire. During this process, the ABC was found as part of a binding. YL

Lanhydrock House, Cornwall · ABC Prymer · *London* · *c.1535?* · *17.8 x 11.6cm* · *Quarto* · *19th-century leather and cloth binding* · *NT 3031995*

Above · The fire at Lanhydrock House on 4 April 1881, as shown in an engraving by George Montbard published later that month in the *Illustrated London News*. Much of the house had recently been refurbished.

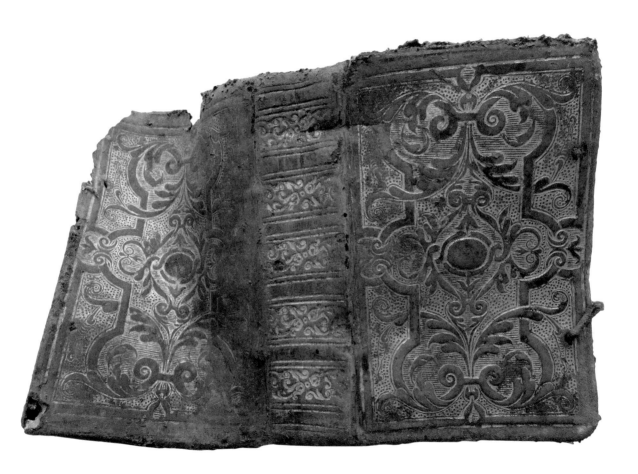

Devotions lost and found

Discovered in summer 2020 under a wall-plate at Oxburgh Hall, home to the Bedingfeld family since 1482, this little volume is a unique survival. The state in which the book was found suggests that it had been dropped a long time ago. Despite missing some pages of text, it retains its 16th-century panel-stamp binding.

This is a small book, intended for private devotions. Henry Wykes (active 1556–69) was the first printer to bring together the three texts contained in this volume: the King's Psalms, The Queens Praiers and The Litany from the Elizabethan Book of Common Prayer. Bishop John Fisher (c.1469–1535) and Thomas à Kempis (c.1380–1471) wrote the first and second texts respectively in Latin. Queen Consort Katherine Parr (1512–48) translated and reworked their texts for a post-Reformation English audience.

After the Northern Rebellion in 1569, when certain Catholic lords fought the monarch's imposition of Protestantism, members of the nobility were required to sign a declaration of obedience to the Act of Uniformity. This made Protestantism England's official faith, and the form of worship was that laid down in the Book of Common Prayer. Sir Henry Bedingfeld (1511–83), the Catholic owner of Oxburgh, had refused to sign the Act. The presence of this book in a recusant household is therefore rather significant. The Bedingfelds remained Royalists, yet privately kept their Catholic faith. YL

Oxburgh Hall, Norfolk · Psalmes or Praiers · *Bishop John Fisher and Queen Katherine Parr · London · 1569? · 10.4 x 6.9cm (closed) · Sextodecimo · 16th-century tanned calf binding with gilt-tooled panel stamp · NT 3059103*

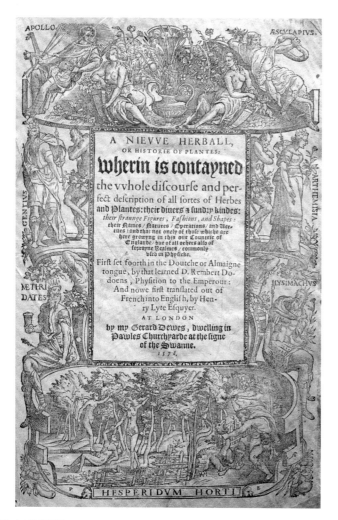

A herbal handbook

Henry Lyte (1529?–1607) was part of a family that had been at Lytes Cary since 1286. He has been described as the first of a long line of British amateur botanists. Although no longer visible, Henry Lyte's garden at Lytes Cary was well known in its day for having all kinds of fruit, including 90 varieties of pear.

Lyte's *Nievve Herball* was an English translation of Crǔÿdeboeck (Herb Book, Antwerp, 1554) by the physician Rembert Dodoens (1517–85). Dodoens was unusual in writing in vernacular Flemish rather than Latin. When translating the work, Lyte compared the 'Douch' version, as he called it, alongside the 1557 translation by Charles de l'Écluse (1526–1609). Lyte's working notes are contained within his copy of the French edition, now in the British Library.

When his translation was complete, Dodoens sent Lyte fresh material, which he incorporated into *A Nievve Herball*. Lyte also added notes about the habitats of some Somerset plants. The whole text was sent to Antwerp to be printed. It reused many of the woodcut illustrations from both the Flemish and French versions. YL

Lytes Cary Manor, Somerset · A Nievve Herball ·
*Rembert Dodoens · London (printed in Antwerp) · 1578 ·
30 x 21cm · Folio · 17th-century calf binding with blind
tooling · NT 3047079 · Given by Simon Every in 2019*

2 The female Peonie at his first springing vp, hath also his stalkes reddish & thicke: the leaues be also large and great, but diuided into more partes almost like the leaues of Angelica, louage, or Smalache. The flowers in this kinde be great and red, but yet lesser and paler then the flowers of the male kinde. The coddes and seede are like the other. In these rootes are diuers knoppes or knottes as great as Acornes.

3 We haue yet another kinde of Peonie, the which is like the second kinde, but his flowers and leaues are much smaller, and the stalkes shorter, the whiche some call Mayden or Uirgin Peonie: although it beareth red flowers and seede lyke the other.

❧ The Place.

The kindes of Peonies are founde planted in the gardens of this Countrie.

❧ The Tyme.

Peonie floureth at the beginning of May, and deliuereth his seede in Iune.

❧ The Names.

Peonie is called in Greeke παιωνία and in Latine Pæonia, of some παιωνία, γλυκυσίδη, Dulcisida, and Idæus Dactylus, of Apuleius Aglaophotis, ἀσβέστη, ὀξυσίφη, ὀξυπόλιον, ωραγωγικός, and Herba casta. In shoppes Pionia: in high Douche Peonien blum, Peonie rosen, Gichtwurtz, Kunigsblum, Pfingstrosen: in base Almaigne Pioene, and Proeublœmen, and in some places of Flaunders Mastblœmen.

❧ The cause of the Name.

Peonie tooke his name first of that good old man Pæon, a very ancient Physition, who first taught the knowledge of this herbe.

❧ The Vertues.

The roote of Peonie dryed, and the quantitie of a Beane of the same taken with Meade called Hydromel, bringeth downe womens flowers, & cureth the mother of women brought a bed, and appeaseth the griping paynes, and tormentes of the belly.

The same openeth the stopping of the liuer, and the kidneyes, and is good against the red wine stopping the belly.

The roote of the male Peonie hanged about the necke healeth, the falling sicknesse (as Galen and many other haue proued) especially in yong children.

Ten or twelue of the red seedes, dronken with thicke and rough red wine, doth stop the red issues of women.

Fifteene or sixteene of the blacke cornes or seedes dronke in wine or Meade, helpeth the strangling and paynes of the Matrix or mother, and is a singular good remedie for them that are troubled with the night Mare (which is a kinde of disease wherin men seeme to be oppressed in the night as with some great burden) and sometimes to be ouercome with their enimies, and it is good against melancholique dreames.

Pæonia mas. Male Peonie.

Pæonia fœmina. Female Peonie.

Of Valerian Phu or Setwal. Chap.lviij.

❧ The kyndes.

There be two sortes of Valerian, the garden and wilde: and the wilde Ualerian is of two kindes, the greate and small: Besides all these there is yet a strange kinde, the which is nowe called Greeke Ualerian.

1. Valeriana hortensis. Serwall or garden Ualerian.

2. Valeriana sylvestris maior. The greater wilde Ualerian.

❧ The Description.

Setwall or garden Ualerian, at the first hath broade leaues of a whitish greene colour, amongst which there commeth vp a round holow playne, and a knottie stalke. Upon the whiche stalkes there groweth leaues spread abroade and cut, lyke leaues of the roote called garden Parsenep: at the highest of ſtalke groweth tuftes of Crownes with white flowers, of a light blew or carnation colour at the beginning and afterwarde white. The roote is as colde as a finger with little rootes and thredes adioyning thereunto.

The great wilde Ualerian, is almost lyke to the garden Ualerian, it hath also playne, round, holow stalkes, diuided with knottes. The leaues are lyke the leaues of Serwall, made of many smal leaues set one against another, lyke the leaues of Setwall or garden Ualerian, whiche growe at the vpper part of the stalke, but much greater and more cloue or cut. The flowers grow and are like the garden kinde, of a colour drawing towardes a light blew or skye colour. The roote is tender winding and trayling here and there, and putting foorth euery yere newe plantes or springes in sundrie places.

The little wilde Ualerian, is very well like the right great Ualerian, but it is

Ff ij alwayes

A Swiss library in Yorkshire

Sabine d'Hervart of Vevey (1734–98) married Rowland Winn (1739–85) in 1761, while he was completing his education in Switzerland. Her family books came to Nostell in 1780 and are a very unusual collection to find in an English country house, where Swiss publications are more usually scholarly classics by famous publishers, such as the Estiennes and Frobens. These books are works in French and German, often on religious, political or practical subjects, including rare survivals of provincial printing.

The volume shown here contains three Swiss and German publications on religious aspects of marriage. It belonged to d'Hervart's great-grand-uncle Hans Jakob Dünz II (1603–68) and probably to her great-great-grandfather Hans Jakob Dünz I (c.1575–1649), who were both artists, originally from Brugg.

At that time, waste paper and vellum from older books and manuscripts were often recycled in bindings. The binder in this case reused a vellum manuscript written in Carolingian minuscule – appropriately a text on virtuous and moral behaviour – thought to date from around the 10th century. This scrap of manuscript is therefore among the oldest items in National Trust libraries. NT

Nostell, West Yorkshire · *Der Christlich Eestand* · *Heinrich Bullinger (1504–75) · Zurich · 1579 · 15.6 x 10cm · Octavo · 16th-century binding, vellum over boards with green silk ties · Inscribed by Hans Jakob Dünz II · Inherited by Sabine d'Hervart, wife of Rowland Winn, 5th Baronet ·* NT 3060510

A lost lesson

In 2003, joiners restoring Hardwick Hall's dining room made a surprising discovery: this small book concealed behind wooden panelling. Thought to be the only surviving copy of *L'ABC des Chrestiens* (Christians' ABC), it was printed by Thomas Vautrollier (d.1587), a Huguenot (French Protestant) who became an important publisher of Protestant theology and educational texts.

The book begins with an alphabet, followed by prayers, the Ten Commandments, and a catechism to prepare for confirmation. There are religious poems and advice on studying and table manners. It is tempting to think that the ABC was deliberately hidden by a child who had become bored with these lessons.

The letters I and J were then used interchangeably so the gold initials on the binding may be those of James Cavendish (*c.*1598–1609), grandson of Bess of Hardwick (1527–1608), the Elizabethan noblewoman who built Hardwick Hall, or they may represent 'Jesus Christ'. NT

Hardwick Hall, Derbyshire · L'ABC des Chrestiens: Avec le Miroir de la Jeunesse · *London* · *1583* · *12 x 8cm* · *Sextodecimo* · *16th-century sheep binding with silk ties* · *Coronet and fleur-de-lis with initials IC* · *NT 3058082* · *‡ 1958*

H Lord Clanebrasill
E his sanguine
scriptum

Written in blood

Blood writing is a long-standing practice in Buddhist manuscripts from the Far East, but in the largely European collections of the National Trust there is only one example. This mysterious inscription (translated as 'Lord Clanebrasill written in his blood'), in an otherwise unassuming textbook copy of the works of Cicero, is in the hand of Henry Hamilton, 2nd Earl of Clanbrassil (1647–75), probably an act of youthful bravado soon after the death of his father in 1659.

With hindsight, the inscription becomes part of the Gothic story of Hamilton's life. In 1667 he married Alice Moore (d.1677), a noted beauty and aspiring rival of Nell Gwyn (1650–87) for the affections of Charles II (1630–85). After persuading the earl to alter his will in favour of her family – against the wishes of his mother, who warned him that it would bring about his swift demise – tradition has it that Moore poisoned her young husband, then had him disembowelled and swiftly buried in Dublin before transferring his corpse to the family tomb at Bangor. TP

Castle Ward, County Down · M. Tullii Ciceronis Opera Omnia Quae Extant · *Cicero · Geneva · 1594 · 19.2 x 12.6cm · Octavo · 18th-century calf binding · NT 3007970*

Dress code

Costume books such as this developed gradually throughout the 16th century. As travel horizons expanded following voyages of discovery, so too did the recording of new places, peoples, their surroundings, habits and appearance. Often regarded as purely visual records of various forms of dress, costume books such as this rare survivor also reflect a growing interest in the relationship between dress and cultural identity around the world.

Diversarum Nationum Ornatus by Alessandro Fabri (active 1593–1600) is a wholly engraved series of plates in three separately published volumes that were later bound together. It includes no descriptive text other than the image captions. Intriguingly, some of the plates have flaps that can be lifted to reveal the detail beneath (opposite).

Although Fabri's title suggests national diversity, his work concentrates on the costumes of Venice and Padua, and those of the different nationalities that passed through these great trading cities. YL

Felbrigg Hall, Norfolk · Diversarum Nationum Ornatus · *Alessandro Fabri* · Padua?, Italy · c.1600 · 17 x 12cm · Octavo · c.17th-century plain calf binding · Library of R.W. Ketton-Cremer (1906–69) · NT 3196728

7 *Cortigiana Veneta*

7 *Cortigiana Veneta*

In sickness and in health

This elaborate velvet binding holds a Bible, prayer book and psalms. Handwritten notes inside give a glimpse into the lives of Lady Anne Sophia Egerton, her daughter Amelia and granddaughter Sophia. Alongside births, marriages and deaths, they describe childhood illnesses and inoculations for smallpox from the 1750s onwards. Sophia's husband, John Cust, 2nd Baron Brownlow (1779–1853), also recorded his grief after her early death and added more family details up to his third marriage in 1828.

This book was closely linked to another Bible (NT 3056025) presented by Queen Mary II (1662–94) to her maid of honour Jane Martha Temple (1672–1751). Together, these books passed down through four generations of descendants from Temple's second marriage to the Earl of Portland, before finding a home at Belton House through her great-great-granddaughter Sophia, Baroness Brownlow. NT

Belton House, Lincolnshire · The Holy Bible · *London · 1613 · 23 x 18cm · Quarto · Sophia Grey, Duchess of Kent (1701–41); Lady Anne Sophia Egerton (d.1780); Lady Amelia Hume (1751–1809); Sophia, Baroness Brownlow (1788–1814) · Red velvet and gilded brass binding; embroidered pad with silk bookmarks · NT 3056653*

THE
TRAGEDY
OF
HAMLET
Prince of Denmarke.

Newly Imprinted and inlarged, according to the true
and perfect Copy lastly Printed.

BY

WILLIAM SHAKESPEARE.

LONDON,

Printed by *W. S.* for *Iohn Smethwicke*, and are to be sold at his
Shop in Saint *Dunstans* Church-yard in Fleetstreet:
Vnder the Diall.

A popular tragedy

Initially an actor, William Shakespeare (1564–1616) later turned to writing plays and poetry, eventually becoming England's most famous playwright. *Hamlet* is one of the most performed of all of his tragedy plays. The prince's 'To be or not to be' speech arguably represents the most powerful moment of self-reflection in dramatic literature.

This rare, undated quarto printing of the text was produced by John Smethwick (d.1641) and William Stansby (1572?–1638). From 1607, Smethwick held the copyright for printing *Hamlet* and some of Shakespeare's other plays. He collaborated with Stansby on printing several of them. Recent research on the printers' devices and paper watermarks indicates that this edition of *Hamlet* was printed in 1625.

The Petworth copy was probably bought fresh from the press during the lifetime of Henry Percy, 9th Earl of Northumberland (1564–1632). Publication dates of the rest of the items in this volume, as well as the 10th Earl's armorial stamp, indicate that they were bound together between 1638 and 1668. YL

Petworth, Sussex · The Tragedy of Hamlet Prince of
Denmarke · *William Shakespeare · London · 1625? · 18.7 x
13.7cm · Quarto · 17th-century sprinkled calf binding · Printed
book label: Earl of Egremont, Petworth · NT 3243821 · ‡ 1956*

A book with two covers

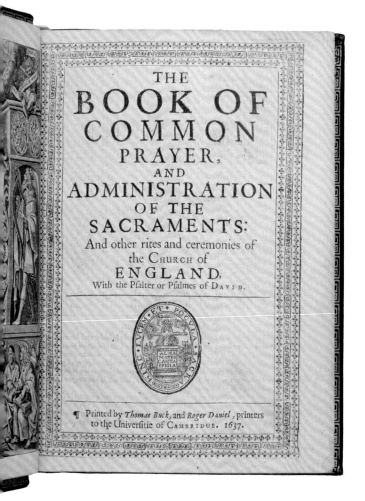

Only rarely are books found with two bindings. This Saltram volume, containing copies of the 1637 Cambridge editions of the Bible, Book of Common Prayer and the Psalms, is a striking example. The beautiful 17th-century velvet needlework binding (overleaf) was kept after the book was rebound in decorated blue morocco leather *c.*1800. Full of religious imagery, the embroidered binding opens up to show the main portraits on each cover: Christ faces Moses holding the tablets containing the Ten Commandments. Corner medallions contain images of saints and, between them, the remains of two coats of arms and the initials AK.

Within the new binding the later owner has added various printed portraits, including that of the poet Anne Killigrew (1660–85, overleaf). The volume also includes additional notes about Anne, whose family came from Cornwall. Although unsigned, the later binding has been tentatively attributed to Christian Kalthoeber (active 1775–1817). YL

Saltram, Devon · The Book of Common Prayer [with] The Holy Bible [and] The VVhole Book of Psalmes: Collected into English Metre · *Cambridge* · *1637* · *52 x 29cm* · *Quarto* · *18th-century blue morocco binding with gilt tooling* · *Initials AK worked into original needlework binding* · *NT 3039440*

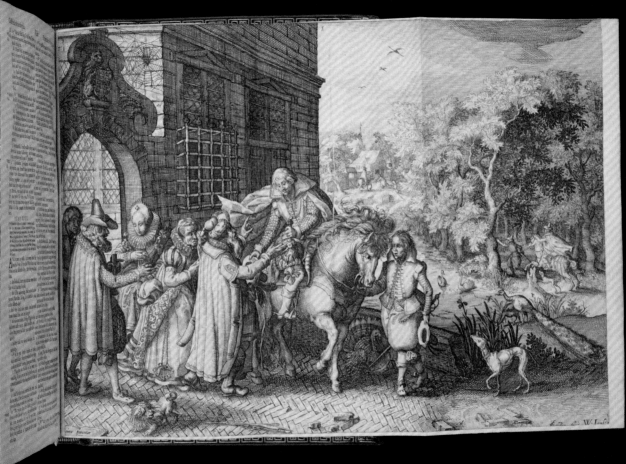

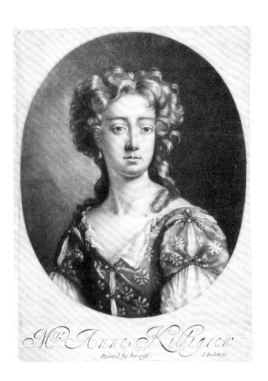

Above · Engraved portrait of the poet and painter Anne Killigrew (1660–85) pasted to the flyleaf of the Saltram volume (NT 3039440).

Right · The earlier binding of the Saltram volume, an embroidered loose cover of metal thread and silk worked on velvet. It shows Christ facing Moses, who holds the tablets containing the Ten Commandments. Corner medallions contain images of saints, two coats of arms and the initials AK.

Portable piety

'Travelling libraries' are portable sets of small-format books, boxed and uniformly bound. Made from the 16th century onwards and ranging in size from six to 160 volumes, few complete sets have survived. Lucy Throckmorton's travelling library, now at Coughton Court, is one of only two surviving smaller sets of six volumes; the other is known as the Fountaine library. The good condition of the Coughton set, which is bound in vellum and shows little sign of wear and tear, suggests it may have been a treasured gift.

The Fountaine and Throckmorton libraries include devotional books printed around 1640. Both have copies of three books in common: *Crums of Comfort*, *The Right Way to Heauen* [Heaven], and *Foode from Heauen*.

Crums of Comfort addresses the theme of moral salvation and the deliverance of the people from various disasters, which are illustrated in the plates, including the Spanish Armada, the Gunpowder Plot and an outbreak of plague in 1625 (opposite).

Housed in matching boxes and bindings, they would have made beautiful gifts for any book-lover. YL

Coughton Court, Warwickshire · Travelling library · *Various authors · London and Cambridge · c.1640 · Box: 18.4 x 13.4cm · Box and books covered in geometrically patterned 17th-century vellum with gilt tooling, coloured leather inlays and onlays · Printed label: Lucy Throckmorton · NT 3243500*

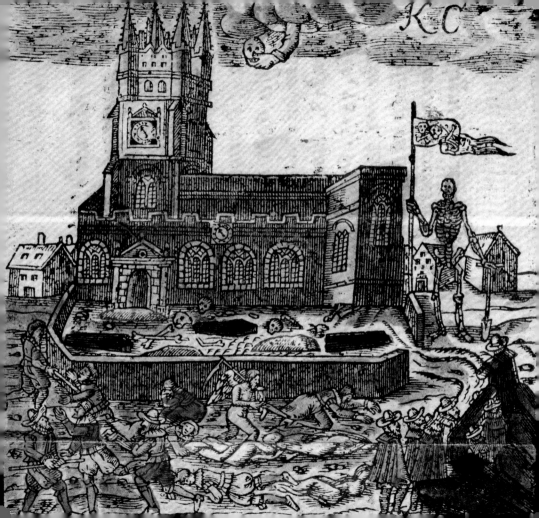

Dancing king

The French king Louis XIV (1638–1715) was arguably the most powerful and influential monarch in Europe, but the early years of his minority were fraught with a series of civil wars known as the Fronde (1648–53). Louis and his advisers harnessed the political power of the arts and thrust the young king centre stage of his court through dance.

This volume includes the printed text and 129 drawings for the costumes and stage designs of the *Ballet Royal de la Nuit* (Royal Ballet of the Night), performed in Paris in 1653. It originally belonged to Louis Hesselin (1602–62), the organiser of the event. The ballet was danced by professionals and courtiers, including a young Duke of York, the future King James II of England (1633–1701). The nocturnal ballet was performed over the course of 13 hours in four parts, ending at sunrise with the appearance of Louis XIV as the sun god, Apollo, bringing peace and light after the chaos of the night. The choice was a ploy to manipulate the image of the king, who is still known as the Sun King today. RJ

Waddesdon Manor, Buckinghamshire · Ballet Royal de la Nuit · *Text by Isaac de Benserade (1612–91), drawings attributed to Henri Gissey (c.1621–73) · Paris · 1653 · 34.5 x 24.3cm · 17th-century citron morocco binding with gilt tooling · Waddesdon 3666.1–3*

A Coppy of Verses Made by E Massingberd

*afterwards Wife of S.r Nicholas Stoughton Baronet
She was Daughter of S.r Henry Massingberd & mother of Frances Onslow
Frances y.e wife of Charles Ventris of Campton in y.e County of Bedford Esq.r*

From Our Good God, proceedeth Only Good,
The Boundless, Mercy hath His Seat Above,
His Seat Corrections, Rightly understood,
Are Marks of mercy, for Our God is Love,
Justice from Our Selves; Torment & Hell,
Are from our Want of Love. Study this Well,

This Book to me My
Father did give, and
I will Keep it as long
as I live, when I am
dead ~~right it~~ the ...
and take my book
she keep it well.
Elizabeth
Massingberd is
my name and
with my pen
I writt the same,
and if my pen had been
better I would a mended
every letter, an o°d
1656.

A father's advice

This book, written for his family by Henry Massingberd of Gunby (1609–80), provided religious teachings in keeping with the Commonwealth then governed by Oliver Cromwell (1599–1658). Massingberd also included poems marking personal events such as the death of his wife Elizabeth Lister (d.1643) after the birth of their ninth child.

Massingberd supported Parliament during the English Civil War and was created a baronet by Cromwell. His poem 'Civill Warre' makes a plea for tolerance, advising impartiality to 'end debate and strife'. After the Restoration of the monarchy, Massingberd took his own advice, staying in favour with Charles II (1630–85), who re-conferred the baronetcy in 1660.

Massingberd presented this copy to his 16-year-old daughter Elizabeth (1640–82), who wrote a charming verse ownership inscription (left). It passed down through her family to her great-grandson Charles Ventris Field. NT

Gunby Hall, Lincolnshire · The Counsell and Admonition of Henry Massingberd Esq. to His Children · *Henry Massingberd · London · 1656 · 27 x 18cm · Folio · 17th-century calf binding · Elizabeth Massingberd, who married Sir Nicholas Stoughton (1634–86) · Armorial bookplate of Sir Charles Ventris Field (d.1803) · NT 3060908*

THE
COUNSELL
AND
ADMONITION
OF
HENRY MASSINGBERD, Esq;
TO HIS
CHILDREN.

PSAL. 111. 10. PROV. 9. 10.
*The fear of the Lord is the beginning of wisdome, a good understanding have all
they that doe thereafter.*

PROV. 4. 7.
*Wisdome is a speciall thing, therefore get wisdome, and above all thy gettings get
understanding.*

TIT. 1. 15.
To the pure all things are pure, but to the corrupt all things are corrupted.

There may be both good and evill produced from all earthly things, for that Every pot
hath two handles. *Char. of Wisd.*

LONDON,
Printed by *A.M. Anno Domini* 1656.

God Saue the King I Say

David Dyer Amen for bee it
or for it is
g amen p

Jo: Hughes

Great escape

Early on the morning of 8 September 1651, King Charles II (1630–85) was ushered into Moseley Old Hall, one of a series of safe houses that sheltered him following his defeat at the Battle of Worcester (1651). Weary and in constant danger of being discovered, Charles spent two days at Moseley, sometimes hiding in the house's priest hole, before continuing his five-week escape to France.

Charles's cross-country flight is recounted in great detail in *Boscobel*, which its author, Thomas Blount (1618–79), described as 'an history of wonders'. This copy was owned quite soon after publication by the Pennants, a proudly Royalist family from North Wales, whose patriarchs had fought for Charles I (1600–49) at Denbigh and Anglesey. The three small ink portraits at the front of the book may well be the sons and daughter of David Pennant, the High Sheriff of Flintshire in the early 1640s. The children, Pyers, John and Mary, would have been familiar with and exhilarated by the story of Charles II's daring adventures. TP

Moseley Old Hall, Staffordshire · Boscobel: or,
The History of His Sacred Majesties Most Miraculous
Preservation · *Thomas Blount · London · 1660 · 11.3 x 7.3cm
· Octavo · 17th-century calf binding · NT 3046950*

The heavens in glorious colour

Published during the golden age of Dutch cartography, the *Harmonia Macrocosmica* is one of the most well-known star atlases of the 17th century. Its author, the relatively unknown Andreas Cellarius (*c.*1596–1665), intended it to be the seventh and final volume of the atlas of the entire known cosmos compiled by Gerard Mercator (1512–94). After Mercator's death, Amsterdam cartographers Johannes Janssonius (1588–1664), Henricus Hondius (1597–1651) and then Cellarius continued his work.

With its beautiful hand-coloured plates, the *Harmonia,* or *Atlas Coelestis,* was (and remains) one of the most visually appealing books of its kind. It is a compilation of the work of the great cosmographers, from Ptolemy's *Almagest* or star catalogue of AD150, to the discovery by Nicolaus Copernicus (1473–1543) that the earth orbited the sun. Criticised at the time for celestial inaccuracy, it remained neutral in the debate on whether the earth or sun was at the centre of the solar system. YL

Blickling Hall, Norfolk · Harmonia Macrocosmica · *Andreas Cellarius · Amsterdam · 1661 · 52 x 36cm · Folio · 17th-century Dutch vellum binding over boards with gilt tooling · Library of Sir Richard Ellys of Nocton (1682–1742) · NT 3242709 · ‡1940*

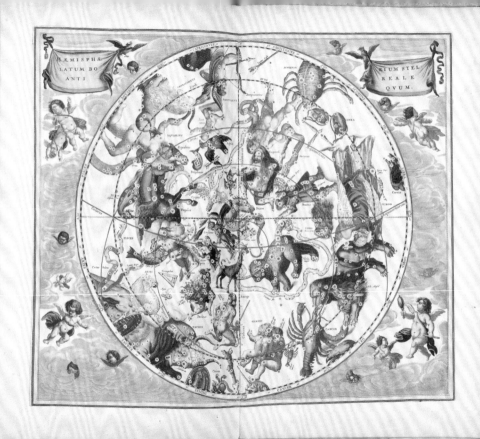

HAEMISPHAERIUM STELLATUM BOREALE ANTIQUUM

CORPO COELE MAGNI | RUM STIUM TUDINES

SCENO SYSTEMATIS PTOLE | GRAPHIA MVNDANI MAICI

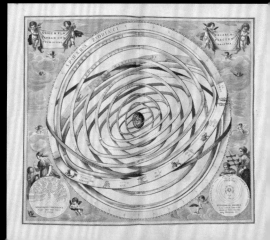

The virtues of the Hebrews

This volume, an important defence of Judaism by the Portuguese doctor Isaac Cardoso (c.1603–83), was owned by the author and bibliophile Isaac D'Israeli (1766–1848). His extensive notes are inserted between the pages of the book, the author of which happened to be a distinguished forebear of D'Israeli's wife, Maria (1774/5–1847). Bookplates at both front and back provide the volume with an impressive British Jewish lineage, ascribing prior ownership to David Alves Rebello (1741–96), a merchant from Hackney whom Isaac knew through the Bevis Marks Synagogue.

In 1813 a disagreement with the synagogue led Isaac D'Israeli to distance his family from the congregation, although he continued to engage with Jewish literature and his family's heritage throughout his life. His 1833 publication, *The Genius of Judaism*, which advocates a reformation of rabbinic tradition, leans heavily on Cardoso's book and on other Jewish texts that he collected. The significance of these works to Isaac D'Israeli is suggested in their selection by his son, Prime Minister Benjamin Disraeli (1804–81), for very prominent inclusion in his library at Hughenden Manor. TP

Hughenden Manor, Buckinghamshire · Las Excelencias de los Hebreos · *Isaac Cardoso · Amsterdam · 1679 · 21.2 x 17.6cm · Quarto · 19th-century sprinkled calf binding with gilt-tooled spine · Bookplate of The Right Honourable Benjamin Disraeli · NT 3071725*

PRIMERA

EXCELENC...

HEB...

Pueblo...

D...

Y à vos tomó el Señor por...
Santo tu al Se...

S la primera Exce...
los Hebreos, el...
escogido del Se...
todas las nacion...
para servicio...
cantar sus divinas alaba...
dize por su Propheta,...
para mi, mi loor recontará
Adam, y de Adam cr...
todos los dones de...
gracia, iluſtrados de...
ra y ſapiencia, for...
Sagrada para Orig...
y Sello y admirac...
ponelos en el Pa...
rioſo Jardin de...
cultiven y gua...
ocio en aquel...
ſolo un prece...
bol vedado...
del mal, para...
minio de ſi...
ger engañ...
bre de la...
gañados...

(handwritten note, partially legible)

Index to Cardoso

Circumcision — pa. col
Hebrew origin of them 3-2
Dispersed — thought he 3-1
So Ezra states, any there
Romans, not short } 9-1
Description of the present miserable State of the Jew } 13-1
Frederick Emp XII — 15.2
Strabo — 16-2
Jewish names of Spanish Chr... } 17.2
Mount Sinai a model of the Temple 129-1
God of Israel not God of others — 36-1
their Ghetto — 47.1
Bithom w... like a pebble but dies like a few — 48.2
Origin & necessity of the Traditionary Law } 135.2

This booke was the gift of my
Brother the Deane of Carlisle to
mee when I was prisoner in
Newgate after my condemnation.
1655. It belonged to the Chappel
of ye Princesse Anne of Denmarke,
whose Chaplaine hee was. ~

A Jacobite's prison diary

After the Glorious Revolution of 1688 deposed James II (1633–1701) in favour of his daughter Mary (1662–94) and her husband William of Orange (1650–1702), James's supporters worked towards his restoration. In January 1691 Richard Graham, 1st Viscount Preston (1648–95) was arrested while carrying letters and documents to James's exiled court in France and sentenced to death for treason.

Preston records that this prayer book was given to him by his brother William Graham (d.1712/3) and came from the private chapel of Princess Anne of Denmark, later Queen Anne (1665–1714). In it Preston wrote a short diary of his time in Newgate prison, noting significant events such as his wife's efforts to gain him a pardon and the execution of a fellow conspirator. In June 1691 Graham was pardoned when he confessed and implicated others. After his death at Nunnington, the book passed to his daughter, Lady Catherine Widdrington (1677–1757), and down through the family. NT

Nunnington Hall, North Yorkshire · Book of Common Prayer · *Church of England · London · 1688 · 17.5 x 11cm · Octavo · 17th-century calf binding with monogram of Princess Anne of Denmark; in a later velvet box inset with 17th-century embroidery · NT 3131076 · Given to the National Trust by Alexander and Richard Hamilton*

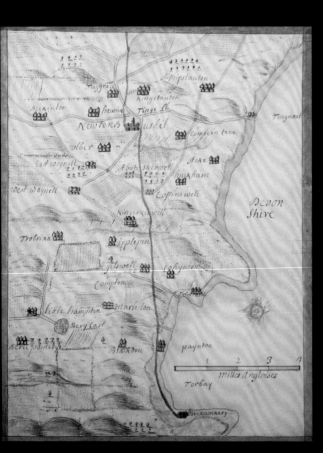

On the road to London

Hand-written and illustrated around 1689, the manuscript shown here records the arrival in England of William of Orange (1650-1702) and the march of the Dutch army towards London. Written in French, it is a daily account of the progress of William's army. The manuscript is divided into two halves: first the descriptive text written in daily journal style, then hand-coloured maps showing the route taken by the army.

William brought with him a large Dutch army, and was expecting support from English opponents of James II and his Catholic policies. As can be seen in this text, the British contingent of 'My Lords Angloiss' and 'My Lords Escossois', arrived ten days into the march. Between text and maps coloured to show different regiments, we can follow the troops' progress into London.

Although William Blathwayt was William's minister for war, it isn't clear if this account was written specifically for him. It bears Blathwayt's distinctive library shelf-mark, placing it at Dyrham Park in the early 1700s at the latest. YL

Dyrham Park, Gloucestershire · Cartes de la Marche qu'a Fait l'Armée de Son Altesse Royalle Monseigneur Le Prince · 1689? · 24.6 x 32cm · Oblong folio · 17th-century sprinkled calf binding · Library of William Blathwayt

Coping with loss

Although death in early childhood was relatively common before modern medicine, this would not have lessened the profound grief of bereaved families. *A Token for Mourners*, first published in 1674 by John Flavel (1630–91) and republished many times, offered Christian consolation and advice.

Anne Longmire (d.1700) and Benjamin Browne (1664–1748) of Townend had eight children, five surviving to adulthood. A contemporary note shows that the *Token* was given to Anne by her brother-in-law Bryan Philipson (d.1719), probably to help her cope after the death of a daughter. Sadly, Anne herself died shortly after the birth of daughter Mary, who also died soon afterwards.

A note records that James Longmire (Anne's brother d.1753) had swapped this book for *The Sincere Convert*; similar notes in other Townend books offer intriguing evidence of their circulation in this Lakeland community. NT

Townend, Cumbria · A Token for Mourners · *John Flavel · London · 1690 · 14.3 x 8.6cm · Duodecimo · 19th-century half red morocco and marbled paper binding by George Browne (1834–1914) and William Jackson Browne (d.1890) · James Longmire, Bryan Philipson · NT 3075553*

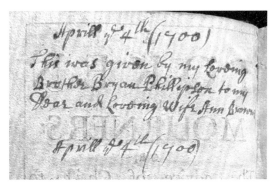

Masters of all they surveyed

Joel Gascoyne (1650?-1705) was one of the great land surveyors, chart makers and cartographers of his age. After he established his own chart-making business in 1675, his advice was sought by Samuel Pepys (1633-1703), secretary to the Admiralty and famous diarist. Due to increasing competition from printed charts, Gascoyne began to concentrate on land surveying.

In the 1690s he mapped, among others, the estates of James Cecil, 3rd Earl of Salisbury (d. 1683) and the royal manor of East Greenwich on behalf of Samuel Travers (c.1655-1725), surveyor of land revenue to King William III (1650-1702) and Queen Mary (1662-94). Travers introduced Gascoyne to local families in need of estate surveys and maps. He surveyed the Robartes family estates on behalf of Charles Bodvile Robartes, 2nd Earl of Radnor (1660-1723), producing 258 hand-coloured maps on vellum in four large volumes and his fieldwork was published in 1699 as the first large-scale, one-inch-to-the-mile county map. YL

Lanhydrock House, Cornwall · The Lanhydrock Atlas ·
Joel Gascoyne · Cornwall · 1694–c.1699 · 61 x 45.8cm · Folio ·
Rebacked 18th-century reverse calf binding with labels on front
covers · Library of the Robartes family of Lanhydrock from
creation until given to the National Trust in 1964 by Gerald
Agar-Robartes, 7th Viscount Clifden · NT 884808

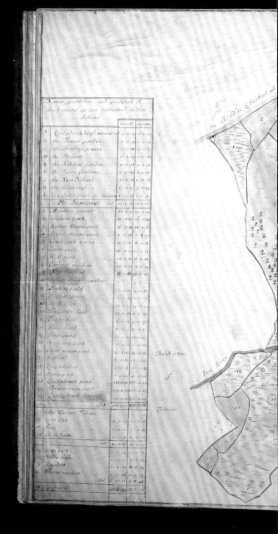

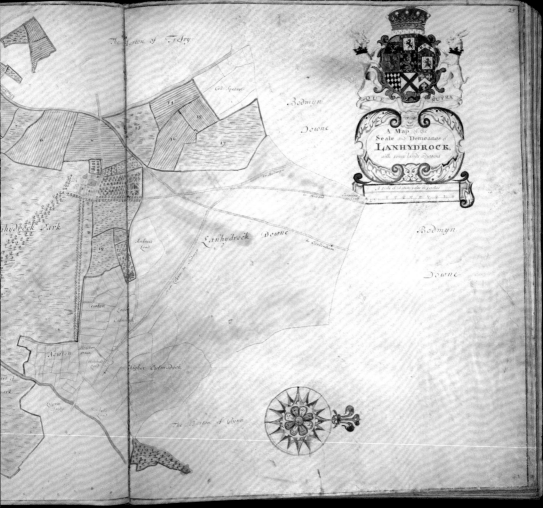

The Barton of Tredry

The Barton of Tredry

Col: Spereet

11

16

13

17

Ac:

Bodmyn

Downe

A Map of the
Seate and Demeanes of
LANHYDROCK
with some lands adjacent

A Table of all Acres of the parishes

Lanhydrock Park

Amberds
Land

Lanhydrock Downe

Bodmyn

Downe

19

carton

Newton

Houton
mere

Higher Colmadock

Stern
Bridge

Red Ash

The Barton of Glynn

The fascinating little book shown here, originally written in French by Melchisédech Thévenot (c.1620–92) – a French diplomat, cartographer and inventor of the spirit level – was one of the first works published on swimming. It gives detailed instructions on how to swim and dive safely in lakes and rivers, accompanied by charming plates of naked men and women demonstrating the various methods. The illustrations are copied from the 1696 French edition but have been reversed, probably a sign that they are unofficial reproductions.

Anyone who has read modern guides to wild swimming will recognise many of the instructions, such as being aware of water temperature and checking for obstructions. The strokes demonstrated include doggy paddle and breaststroke, which this book helped to popularise. There is also advice on how to sit, to float, to save yourself if your feet get trapped by weeds, and even how to cut your toenails while in the water. The anonymous English translator added a chapter with advice on lifesaving using 'several portable engines' to keep you afloat. NT

Kedleston Hall, Derbyshire · The Art of Swimming · *Melchisédech Thévenot · London · 1699 · 16 x 9.5cm · Duodecimo · 18th-century calf binding · NT 3114492*

XV P. 34.

XIV P. 33.

XVII P. 36.

V P. 22.

Thomas Palmer esqr died 1734 without publishing anything relating to this county his library was sold to Sr William Wyndham for 600 a fine collection

But where his mss and collections are proposals for printing a general and particular description account of the county of somerset and city of Bristol by what most infamous notorious lying Rascal John Strachey collector of his majestys customs in the port of Bridgewater. the books are promised to be delivered in 1722, mich: and not one has been to this day and 1 yr. 30: 1738 I dare say the villain never wrote a line. —

X are now in the Harley Library. marked 124. B.2 the Title wrote by John Anstis is. Abridgement of the Inquisitions post mortem or escheat Rolls of the Tenants from the crown in the counties of somerset and Dorsett from the Reign of Henry the third to Richard. the third both inclusive.

SOMERSETSHIRE.

PRoposals formerly have been publish'd, for a Natural History of this County by Mr. *John Beaumont*, who has given a Specimen in his Letter concerning *Ochey-Hole*, and other Subterraneous Grotto's in *Mendip-Hills*, printed in *Numb.* 2 of the *Philosophical Transactions*, in 1681. *Thomas Palmer*, *Esq*; a Native of this County, is given out to have undertaken the Description of this Shire. As for particular Places: *Ochey-Hole*, near *Wells*, has been described in 1632. And the City of *Bath*, her Antiquities, Waters, &c. have employ'd many Pens. The first who wrote on the Nature of the Waters, was Dr. *William Turner*, who publish'd a Piece — *De Thermis Bathoniensibus, &c. Colon. Aggripin.* 1562. *Folio.* — To the — *Via Recta ad vitam longam: Or, A Treatise wherein the Right Way, and best Manner of Living, for attaining to a long and healthful Life, is clearly demonstrated. Lond.* 1650, *&c.* 4to, is added, — *A Compendious Treatise, concerning the Nature, Use, and Efficacy of the Bathes at Bath.*

P 4 — A

see Inquisitions post mortem in the hands of Tho. Rawlinson 2 where now X are

By Tobie Venner

During her restoration of Wimpole Hall, Elsie Bambridge (1896–1976) bought this volume, perhaps because it came from the library of Edward Harley, 2nd Earl of Oxford (1689–1741), who reputedly kept all his printed books at Wimpole. *The English Topographer* by Richard Rawlinson (1690–1755) is exactly the sort of book Harley would have appreciated in his collection. An account of Rawlinson's travels and researches relating to English history and antiquities, it mirrored Harley's own interests in those fields.

The book was sold after Harley's death in 1741, possibly in the series of London sales of his collections. This copy includes a letter from one Charles Wright 'To Messrs Puttick and Simpson', the London booksellers, stating that this copy is 'Interleaved and abounding in frequent notes by the Second Harley Earl of Oxford'. At some stage, a number of the additions have been removed, presumably before Elsie Bambridge bought the book. YL

Wimpole Hall, Cambridgeshire · The English Topographer · *Richard Rawlinson* · *London* · *1720* · *21.7 x 17.1cm* · *Thick octavo with additional interleaved blank sheets of paper, some with annotations* · *Late 19th-century polished tanned calf binding over boards* · *Pictorial bookplate: Ex Libris Jacobi D.R. Lyell* · *NT 3109523*

An adventuring Islamicist

'He recently made a miniature saucepan of gold for the Queen's dolls' house.' This one-line obituary of Harold Lyon Thomson (1860–1924) downplays a life full of incident and achievement, but does reflect its eclectic nature. The son of Robert Thomson (1822–73), the inventor of the pneumatic tyre, Harold travelled the world, becoming embroiled in local politics wherever he found himself (in later life he became Mayor of Westminster). During his time in Cairo, while serving as secretary to the Ottoman ruler, he studied Islamic literature and began collecting books and manuscripts.

After his death, much of his library passed onto the shelves of his brother's home, Dorneywood, including this manuscript copy of the works of the Shirazi writer Sa'dī (c.1210–c.1291). Revered across the Islamic world, Sa'dī's longform poems and prose (including his most famous work, the *Golestān*), together with his odes and love poems, are a fundamental element of Persian literary history and would have formed an essential part of a budding Islamicist's education.

Despite the presence of some ornate illumination, this is an unpretentious manuscript, designed to be read rather than treasured, although its 19th-century French binding, supplied by Silvestre de Sacy (1758–1838), the famous collector of Islamic material, has given it an air of European grandeur. TP

Dorneywood, Buckinghamshire · Kolliāt · *Sa'dī* · *India* · *No later than 1732* · *31.5 x 22.4cm* · *19th-century green morocco binding with gilt decoration* · *Book labels of Silvestre de Sacy and Chevalier Ferrão de Castelbranco (d.1849)* · *NT 3125095*

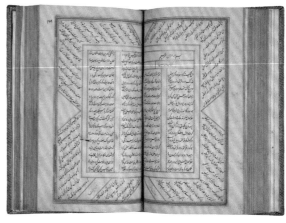

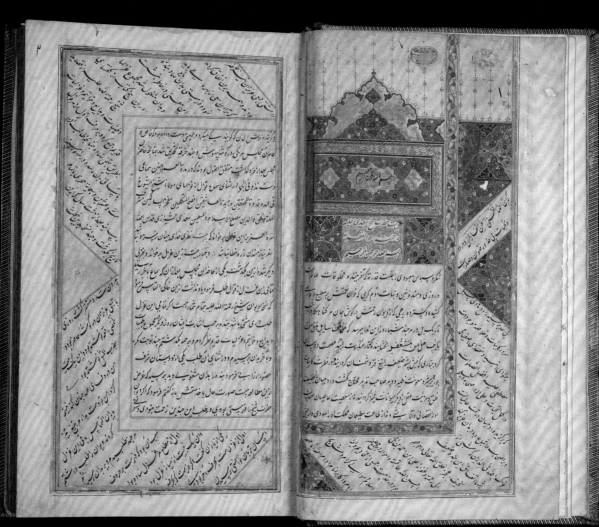

181

la plaisanterie n'est pas sans fondement.

209

experience curieuse, ou l'Abbé Nolet.

A book of dangerous laughter

Containing 387 drawings, *Livre de Caricatures tant Bonnes que Mauvaises* (Book of Caricatures Good and Bad) is a unique survival from an age of powerful censorship. Had the authorities discovered its existence, it would have been destroyed, and its authors, at the very least, imprisoned in the Bastille.

Charles-Germain de Saint-Aubin (1721–86) was embroidery designer to King Louis XV (1710–74) and depended on the court for his livelihood and status. The Book of Caricatures reveals quite another side to him and the small group of intimates who collaborated in its making. Its enormous cast includes churchmen, soldiers, scientists, street sweepers, executioners, artists, writers and collectors. Saint-Aubin's principal patrons are among the most frequent targets, not least the king's mistress Madame de Pompadour (1721–64). Also known as 'The Book of Arses', it is peppered with visual jokes about the mechanisms of the human body, and encompasses imagery from carnival to high culture. JC

Waddesdon Manor, Buckinghamshire · *Livre de Caricatures tant Bonnes que Mauvaises* · *Charles-Germain de Saint-Aubin and others* · *Paris* · *c.1740–c.1775* · *19.6 x 14cm* · *19th-century green morocco binding with gilt tooling* · *Waddesdon 675*

'Next year in Jerusalem!'

An unusual item to find in an English collection, this Jewish text probably came from the library of Richard Ellys of Nocton (1682–1742), which was bequeathed to his second cousin Sir John Hobart (1693–1756), 1st Earl of Buckinghamshire.

In northern and central Europe during the 18th century there was a flourishing market in the craft of writing and decorating Hebrew manuscripts. The well-known artist and scribe Joseph ben David (active 1731–40), originally of Leipnik in Moravia (in the modern-day Czech Republic), created this manuscript in Altona, near Hamburg. Known as a Haggadah, it contains texts and images of the Ashkenazic and Sephardic rites of the Passover, which celebrates the Exodus of the Jews from Egypt.

Read during a festive meal on the first two nights of the Passover festival, the text ends with the blessing 'Next year in Jerusalem!' This copy is illustrated with 64 full-colour images that are closely linked to the text. YL

Blickling Hall, Norfolk • Order of the Passover Haggadah (known as the Leipnik Haggadah) • *Joseph ben David* • *1739/40 • 36 x 25.8cm • Folio • 18th-century gilt-tooled goatskin binding* • NT 3070293 • ‡1940

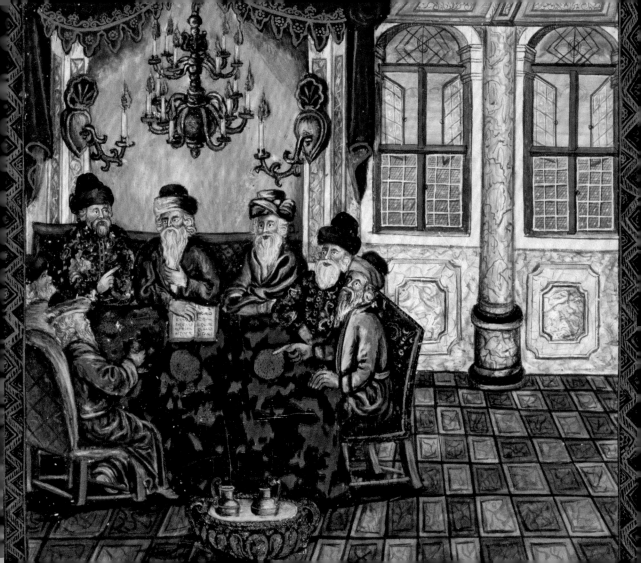

A literary treasure trove

Open this handwritten volume from one end and you find a collection of short extracts from poems or writings that caught the compiler's eye, perhaps the historic equivalent of Pinterest. Turn it around and there are longer sermons and poems by contemporary writers, including two poems in the handwriting of author and clergyman Laurence Sterne (1713–68), best known today for his comic masterpiece *Tristram Shandy* (1759).

'Epitaph upon an Old Toper' – which relates the drunken habits of Peter, perhaps a friend or parishioner, whose 'taste was all for liquid' – was unknown until this volume was catalogued in the 1990s. Another poem, describing an epidemic of cattle disease in Sterne's Yorkshire parish, is known in only two variant copies.

Other items in this intriguing volume include a satirical poem on a literary salon in Bath (published by Humphry Repton (1752–1818), better known for his landscape designs), a quirky epitaph for an Irishman, a poem by actor David Garrick (1717–79), and an advertisement for 'Patent Ventilating Breeches' to help cool gentlemen riding during hot weather. NT

Belton House, Lincolnshire · Manuscript Collection of Works by Various Authors · *England* · *c.1740–80* · *26.5 x 20cm* · *18th-century calf binding with pasted marbled paper* · *NT 3053478*

Contents of this End of the Book

THE

Complete House-keeper,

AND

PROFESSED COOK.

CALCULATED

For the greater Ease and Assistance of Ladies, House-keepers, Cooks, &c. &c.

Containing upwards of

SEVEN HUNDRED practical and approved RECEIPTS, under the following Heads:

I. Rules for Marketing.	V. Potting and Collaring: As pikes in Jellies; savoury Cakes, Blamonge, Ice Creams and other Creams, Whips, Jellies, &c.
II. Boiling, Roasting, and Broiling Flesh, Fish, and Fowls; and for making Soups and Sauces of all Kinds.	
III. Making made Dishes of all Sorts, Puddings, Pies, Cakes, Fritters, &c.	VI. Bills of Fare for every Month in the Year; with a correct List of every Thing in Season for every Month; illustrated with two elegant Copper-plates of a First and Second Course for a genteel Table.
IV. Pickling, Preserving, and making Wines in the best Manner and Taste.	

By MARY SMITH,

Late House-keeper to Sir Walter Blackett, Bart. and formerly in the Service of the Right Hon. Lord Anson, Sir Tho. Sebright, Bart. and other Families of Distinction, as House-keeper and Cook.

NEWCASTLE:

Printed by T. SLACK, for the Author. 1772.

How to shop and cook

Mary Smith (active 1749–77) probably began writing this cookbook while working for Sir Walter Blackett of Wallington (1707–77). Little is known of Smith's life, but her introduction stressed that the recipes came from 23 years' experience as cook and housekeeper to 'families of distinction'. While focusing on traditional English dishes and preserving techniques, her 'elegant and œconomic' recipes show French and Italian influences and include sophisticated showpiece puddings, giving an insight into the meals served at grand houses such as Wallington. Smith also included seasonal menus and advice on shopping, explaining how to check meat and fish for freshness.

This practical cookbook shows clear evidence of use, including a handwritten recipe for 'custard pudding', markers at 'Foe graw' (foie gras) and 'Burnt cream', and food stains. Charles Trevelyan has also noted the coincidence that Wallington's cook in the 20th century was another Mary Smith. NT

Wallington, Northumberland · Complete House-keeper and Professed Cook · *Mary Smith · Newcastle upon Tyne · 1772 · 20.5 x 13cm · Octavo · 20th-century morocco binding · Bookplate of Sir Charles Philips Trevelyan (1870–1958) and Mary Trevelyan (1881–1966) · Gift to the Trevelyans from Captain Ralph Blackett (1877–1964) · NT 3066441*

~~~~~~~~~~~~~~~~~~~~~~~~~~~~~~~~~~~~~~~~~~~~

# THE
# PREFACE.

FROM *the many repeated Solicitations to publish a Book of Receipts from my own Practice, I at last complied, and have, with much Application and Trouble, completed the Work. Should it prove useful to the Public, and merit their kind Indulgence, I shall think my Labour well bestowed.*

*As this Work is calculated to convey the practical Knowledge of Cookery, Pastry, Pickling, Preserving, &c. (which is founded on the actual Practice of twenty-three Years, as Housekeeper and Cook to several Families of Distinction) nothing, I presume, on the like Subject, will be found of more Utility to a Family; the whole being conducted with the greatest Oeconomy and Elegance.*

*The Public may be assured, that this Work is not a Compilation of Receipts from any Author, but entirely deduced from my own Practice and Knowledge, which I have*

---

## For MAY.

### FIRST COURSE.

Rice soup removed with stewed
carp and white sauce

| | | |
|---|---|---|
| Beef collops | | Two small chickens boiled |
| | Turnips | |
| Wine sauce | | Parsley and butter |
| Plumb pudding | | Sheep's rumps & rice |
| | Pig roasted | |
| Plain butter | | Currants for the pig |
| Tongue boiled | Colliflower | Pigeon in the form of a moon |

Loin of veal roasted

~~~~~~~~~~~~~~~~~~~~~

SECOND COURSE.

Green goose

| | | |
|---|---|---|
| Custards | | Fricassee of lobster |
| | Potted veal | |
| Rasps in jelly | | Strawberries |
| Green pease | | Artichokes |
| | Desert frame | |
| Cherries | | Preserved green gages |
| | Marinade eggs | Green gooseberry tart |
| Fried smelts | | |

A leveret roasted

Burnt CREAM.

BOIL a pint of cream with a little sugar, and a bit of the rind of a lemon; then beat the yolks of six eggs and the whites of three; when the cream is cold, put in the eggs, with a spoon full of rose water,—set it over the fire, and keep stirring it 'till it is thick; pour it into a dish, and when it is cold, sift some sugar on the top; then hold a hot salamander over it 'till it is very brown, and serve it up for a second course.

This is crême brulée

RHENISH CREAM.

PUT one pint of Rhenish wine in a stew-pan, with a stick of cinnamon, the juice of two Seville oranges, the yolks of six eggs, and half a

MALME'S SONATAS
DEDICATED TO
MISS ERSKINE

Dedicated to Miss Erskine

During the latter part of the 18th century, it was common practice for music composers to dedicate their printed music to aristocratic women. Dedications were beneficial to both parties: the composer's association with an illustrious woman might encourage extra sales, more work and further patronage, while the dedicatee could bask in the pride of knowing that her music was being played in grand houses across the country.

Some composers went a step further than a simple dedication. George Malme, a little-known musician who was the organist at Grosvenor Chapel in Mayfair during the late 1790s, not only dedicated these six sonatas to Lady Mary Henrietta Erskine (1764–1820), but had the elegantly printed sheet music bound in an expensive dedicatory binding. Such a step suggests that 'Miss Erskine' was a valuable patron to Malme, as well as being one of his students. TP

Killerton House, Devon · Six Sonatas for the Harpsichord or Piano-forte · *George Malme · London · c.1776–81 · 27 x 35.5cm · Oblong quarto · 18th-century green morocco binding with presentation label and gilt decoration · NT 3046143*

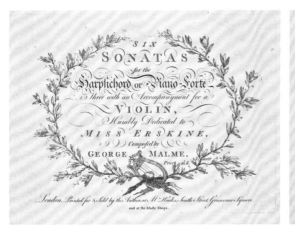

An improving book

The influential wood engraver Thomas Bewick (1753–1828), best known for his accurate depictions of animals, produced illustrations for a wide variety of books. He used a metal tool called a burin to cut into the hard end-grain of boxwood, which allowed precise detail to be carved at very small scale. The collections now at Cherryburn (Bewick's childhood home) include some of his engraved wooden blocks, from which prints can still be made.

Bewick illustrated many small books for children, commissioned by local publishers. This anonymous collection of moralistic fairy tales was intended to make children 'wise, good and happy' and has an illustration for each story, including five early woodcuts by Bewick.

Early children's books were often read until they fell apart and then thrown away. The copy shown here is the only known survivor from this issue. Its owner wrote the name Mary several times, perhaps practising her handwriting. NT

Cherryburn, Northumberland · The Mirror; or A Looking-Glass for Young People of Both Sexes · *Mother Goose* · *Newcastle upon Tyne* · *1778* · *14 x 8.5cm* · *Duodecimo* · *18th-century quarter leather and marbled paper binding* · *Inscribed: 'Mary Ann Hilton July 26th 1784'* · *Bookplate of Justin G. Schiller (b.1943)* · *NT 3043896*

THE
MIRROR;
OR A
LOOKING-GLASS
FOR
Young PEOPLE of both Sexes;

To make them WISE, GOOD, and
HAPPY.

CONSISTING OF

A Choice COLLECTION of

FAIRY TALES.

By MOTHER GOOSE.

NEWCASTLE UPON TYNE:
Printed by T. SAINT, for W. Charnley, in
the Groat-market; and M. Vesey and
J. Whitfield, at Tyne Bridge End.

MDCCLXXVIII.

Verse

The noise of For — — eigh wars The noise of

The noise of Fo — — reign wars The noise of

Fo — — reign wars the whispring of home jealousies & fears

Chorus

The noise of Fo — reign Fo — reign

An unknown ode

Despite a limited legacy because of his death at only 36, Henry Purcell (1659–95) is still considered one of the greatest English composers. As organist at Westminster Abbey and the Chapel Royal, he composed music for royal occasions and entertainments in the courts of Stuart monarchs, along with religious music, theatre works and opera.

The Noise of Foreign Wars, composed in 1689 for the newborn son of Princess (later Queen) Anne (1665–1714), is one of three works known today only because it appears in this manuscript. The music was transcribed from Purcell's original scores by the organist and composer Philip Hayes (1738–97). It then passed to another Westminster Abbey organist, the composer Samuel Arnold (1740–1802).

Noted collector Sir Mark Masterman Sykes (1771–1823) gave these volumes to his sister Elizabeth Egerton (1777–1853), an accomplished keyboard player and singer. Much of Egerton's large collection of music survives at Tatton today, along with a harpsichord that was a wedding gift from her brother. Sykes wanted the Purcell manuscripts to return eventually to his celebrated library at Sledmere in Yorkshire, but that collection was sold by his brother in 1824, long before their sister's death. NT

Tatton Park, Cheshire · Anthems, Odes, Operas · *Henry Purcell · England · 1781–5 · 4 volumes · 40 x 26cm · Folio · 18th-century quarter calf and vellum binding · Bought at Samuel Arnold's sale (1803) by Sir Mark Masterman Sykes, 3rd Baronet, and given to Elizabeth Egerton of Tatton Park in 1807 · NT 3044675 · ‡ 1960*

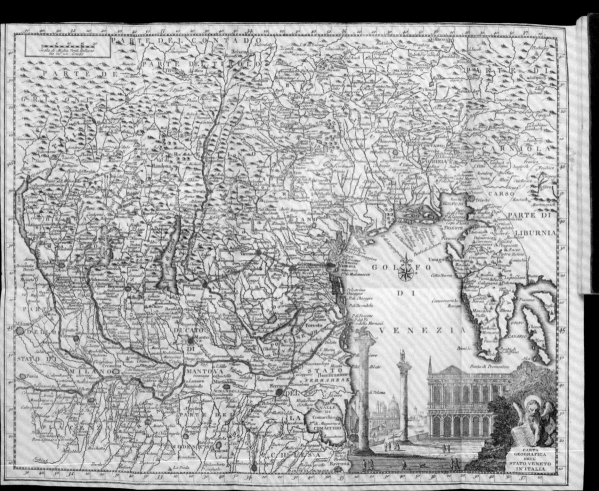

CARTA
GEOGRAFICA
DEL
STATO VENETO
IN'ITALIA

Souvenirs of a grand tour

The grand tour was a recognised way for 18th-century gentlemen to finish their education, travelling around continental Europe with a tutor to experience its varied culture, history and scenery. Their exposure to artistic and architectural ideas had a great influence on British country houses, and many purchases of art and books made on tour are still visible today in Trust properties.

George Harry Grey, later 6th Earl of Stamford and Warrington (1765–1845), kept a detailed journal in 32 volumes of his travels through Europe from the time he left Dover on 4 November 1786 until April 1789. The 21 volumes now at Dunham Massey contain maps and illustrations pasted into the volumes as a visual reminder of his travels. They provide fascinating details of the life of a typical grand tourist.

Grey's diaries contain a mixture of factual information and personal observations. In an entry for September 1787, a charming illustration of a Viennese woman (right) is accompanied by observations on local dress, livestock and the surprising custom of hand kissing. NT

Dunham Massey, Cheshire · Grand Tour Diaries ·
*George Harry Grey, 6th Earl of Stamford and Warrington
· Europe · 1786–8 · 19.5 x 14cm · 18th-century red sheep
binding · NT 3052076*

The pattern of things to come

Primarily a guide for women raising funds or making clothes for charitable distribution, this manual was intended for schools that donated clothing to allow poorer pupils to attend. The anonymous author based the advice on practical experience with industrial schools, where children learnt sewing by making clothes to sell to their parents and others. This gave impoverished families more dignity and also controlled religious education through the children's compulsory attendance at linked Sunday schools.

The book gives advice on buying materials as cheaply as possible and specifies the amounts required for each garment. There are precise measurements for men, women and children – divided into standard sizes in much the same way as ready-made clothing today – and fold-out paper outlines of the pieces to be traced and cut out, the forerunner of tissue paper patterns.

The instructions also cover the items needed by a pregnant woman for her labour and for the baby, including cloth nappies. These were to be lent and returned, as the total cost (£3 13s 5d) was too high for most families to bear. NT

Sizergh Castle, Cumbria · Instructions for Cutting Out Apparel for the Poor · London · 1789 · 22.1 x 14cm · Octavo · c.1800 half calf and marbled paper binding · Bookplate of Jarrard Edward Strickland (1782–1844) · NT 3168922

INSTRUCTIONS

FOR

Cutting out Apparel for the Poor;

Principally intended for the Assistance of the

PATRONESSES of SUNDAY SCHOOLS,

And other CHARITABLE INSTITUTIONS,

But USEFUL in all FAMILIES.

CONTAINING

Patterns, Directions, and Calculations, whereby the most Inexperienced may readily buy the Materials, cut out and value each Article of Cloathing of every Size, without the least Difficulty, and with the greatest Exactness:

With a PREFACE,

Containing a Plan for assisting the Parents of poor Children belonging to SUNDAY SCHOOLS, to clothe them; and other useful Observations.

Published for the Benefit of the

SUNDAY SCHOOL CHILDREN

At HERTINGFORDBURY,

In the County of HERTFORD;

Where the above Plan has been found to be the best Encouragement to the Parents to send their Children to the Sunday School, and at the same Time the best Source of Employment for the Schools of Industry.

LONDON:

Sold by J. WALTER, Charing Cross.

M,DCC,LXXXIX.

Sold at the Parliament Office

Old Palace Yard

Westminster.

Pl. VIII

Fig. 2

a

a

Fig. 1

a

a

Fig. 5

Fig. 4

Fig. 3

Recording ancient trees

The Major Oak in Sherwood Forest (opposite) is now one of the most famous trees in Britain, but its name doesn't come from its size or age. It was thanks to this book – *Descriptions and Sketches of Some Remarkable Oaks, in the Park at Welbeck* – by retired army officer Major Hayman Rooke (1723–1806) that tourists began to visit 'the Major's Oak', previously known as the Queen's Oak, or Cockpen Oak.

Rooke describes it as 'a most curious antient [*sic*] oak', estimating its age at around 1,000 years, but makes no reference to the legend of Robin Hood now linked to the tree. Rooke was a friend of the 3rd Duke of Portland (1738–1809), who owned the Welbeck estates, including part of Sherwood Forest. This area was near the Worksop home of William Straw (1898–1990), who collected books of local interest.

As well as the ten published plates produced from Rooke's drawings, this copy contains several early 19th-century pencil drawings of ancient trees elsewhere in Britain by mainly female amateur artists, and a handwritten account of an ancient chestnut tree on Mount Etna in Sicily. Appropriately, the binding is in a style known as tree calf: the leather is stained in a decorative branch-like pattern. NT

Mr Straw's House, Nottinghamshire · Descriptions and Sketches of Some Remarkable Oaks, in the Park at Welbeck · *Hayman Rooke* · London · 1790 · 27 x 22cm · *Quarto* · 18th-century tree calf binding · Purchased by *William Straw* · NT 3049651

Pl. 9.

Drawn by I. Rooke. Engraved by W. Ellis.

An ancient Oak in Birchland Wood.

Published Dec.ʳ 31. 1790.

SAMUEL JOHNSON.

From the original Picture

in the Possession of James Boswell Esq.

THE

L I F E

OF

SAMUEL JOHNSON, LL.D.

COMPREHENDING

AN ACCOUNT OF HIS STUDIES
AND NUMEROUS WORKS,

IN CHRONOLOGICAL ORDER;

A SERIES OF HIS EPISTOLARY CORRESPONDENCE
AND CONVERSATIONS WITH MANY EMINENT PERSONS;

AND

VARIOUS ORIGINAL PIECES OF HIS COMPOSITION,
NEVER BEFORE PUBLISHED.

THE WHOLE EXHIBITING A VIEW OF LITERATURE AND LITERARY MEN
IN GREAT-BRITAIN, FOR NEAR HALF A CENTURY,
DURING WHICH HE FLOURISHED.

IN TWO VOLUMES.

BY JAMES BOSWELL, ESQ.

—————— *Quò fit ut* OMNIS
Votiva pateat veluti descripta tabella
VITA SENIS.—————— HORAT.

VOLUME THE FIRST.

L O N D O N:
PRINTED BY HENRY BALDWIN,
FOR CHARLES DILLY, IN THE POULTRY.
M DCC XCI.

A token of friendship

Samuel Johnson (1709–84) was one of the most celebrated men in 18th-century England, perhaps best known today for his influential and authoritative *Dictionary* (1755). Bennet Langton (1737–1801) was a founder member of the Literary Club, an exclusive supper group founded for Johnson by the artist Joshua Reynolds (1723–92). The men had met when Langton was still at school, and remained friends until Johnson's death. The personal inscription in this first edition of *The Life of Samuel Johnson* by James Boswell (1740–95) stands as a testament to the friendship between all three men.

The book came to Gunby Hall when Langton's son Peregrine (1780–1858) married Elizabeth Massingberd (1780–1835), who had inherited the estate as a child; Peregrine took the Massingberd surname soon afterwards. Their son Algernon (1803–44) has added his book label to it, perhaps marking his pride in the family connection to the great literary figure.

Peregrine's sister Jane (1775–1854) always wore a portrait medallion of Johnson, who was her godfather. She bequeathed their mother's copy of Johnson's 'oriental tale' *Rasselas* to the Massingberds, and it joined Boswell's *Life* in Gunby's library. NT

Gunby Hall, Lincolnshire · The Life of Samuel Johnson · *James Boswell · London · 1791 · 2 volumes · 28 x 21cm · Quarto · 19th-century half red morocco and marbled paper binding; boxed by Riviere & Son · Given by Boswell to Bennet Langton · Book label of the Reverend Algernon Langton Massingberd · NT 3071259*

A powerful call for change

One of the foundation stones of Black literature is the autobiographical account of enslavement and the Middle Passage by Olaudah Equiano (*c.*1745–97). Equiano's long and detailed narrative is a compellingly written insight into the horrors of slavery.

At a time when few texts were reprinted, this work ran to nine known editions, all published during Equiano's lifetime. Each new edition included revisions and amendments by the author. Funds to publish the book were raised by subscription, the names of the subscribers being included at the end of each volume. With each new edition, the list increased.

In order to generate sales, and to promote the anti-slavery campaign, Equiano embarked on a speaking tour of Britain and Ireland. At the end of the eighth (Norwich) edition, Equiano has included letters from friends and supporters recommending him as a speaker. They also mention that he would bring 'some copies for sale' to members of his audience.

This copy was bought second-hand for five shillings by the Reverend Cremer Cremer (1795–1867), vicar of Beeston Regis. It reached Felbrigg Hall when his descendant Wyndham Cremer Cremer (1870–1933) inherited the property and took his family library with him. YL

Felbrigg Hall, Norfolk · The Interesting Narrative of the Life of Olaudah Equiano, or Gustavus Vassa, the African. Written by Himself · *Olaudah Equiano · Norwich · 1794 · 17.8 x 11.1cm · Duodecimo · 19th-century half calf and marbled paper binding · Inscribed: 'Cremer Cremer Beeston 1837 5/-'* · NT 3210682

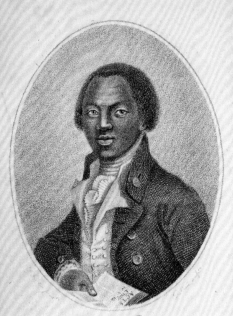

Olaudah Equiano,
or
GUSTAVUS VASSA,
the African?

Published March 1. 1789 by G. Vassa.

THE
INTERESTING NARRATIVE
OF
THE LIFE
OF
OLAUDAH EQUIANO,
OR
GUSTAVUS VASSA,
THE AFRICAN.

WRITTEN BY HIMSELF.

Behold, God is my salvation; I will trust, and not be afraid, for the Lord Jehovah is my strength and my song; he also is become my salvation.
And in that day shall ye say, Praise the Lord, call upon his name, declare his doings among the people. Isa. xii. 2. 4.

EIGHTH EDITION ENLARGED.

NORWICH:
PRINTED FOR, AND SOLD BY THE AUTHOR.
1794.

PRICE FOUR SHILLINGS.
Formerly sold for 7s.

[*Entered at Stationers' Hall.*]

Music for the troops

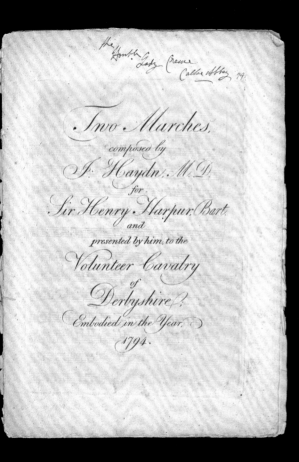

During the French Revolutionary Wars (1792–1802), volunteer regiments were established in England to defend against possible invasion. When the Derbyshire Corps of Yeomanry Cavalry was formed in 1794, Sir Henry Harpur (1763–1819) – then High Sheriff of Derbyshire – became lieutenant of a troop raised on his estate at Calke Abbey. To mark the event he commissioned music from the celebrated Austrian composer Joseph Haydn (1732–1809), then on a successful tour of England. The marches were first privately printed in 1795 to be given to friends and associates, before being published for a wider audience.

Original manuscripts of the final version in the hand of Haydn or his copyist Johann Elssler (1769–1843), marked up by the printer, are now deposited in the Derbyshire Record Office (DRO) along with engraved metal plates used to print the music. These manuscripts and plates are rare surviving examples of music printing practice in 18th-century London. The only known copies of the private publication are at Calke and the DRO. NT

Calke Abbey, Derbyshire · Two Marches, Composed for Sir Henry Harpur, Bart · *Joseph Haydn* · London · 1795 · 36 x 26cm · Folio · Unbound score · Commissioned by Sir Henry Harpur (later Crewe), 7th Baronet · NT 3069686 · ‡ 1985

1 March.

らうら
別れ
つらさ
うらぬ　こと　むゝの
浪むきひた
きみのせて
去年の院電気
不遇恋

待恋

後源衛院参内侍

柱のもとに
それもやひく
きらめも
けぬつらさ
ゆめしらめ

Sukenobu in Surrey

The influence of East Asian art and culture on the country house is easily evidenced by the abundance of Japanese and Chinese motifs and objects, particularly furniture and ceramics, in the National Trust's collections. There is, however, little evidence of the impact of East Asian literature, with only a few volumes of *ukiyo-e* (floating world) prints and 20th-century publications on the library shelves.

This, the Trust's earliest Japanese book, is therefore something of a rarity. Its title in English is *Picture Book of Mount Tsukuba*, and it is by the *ukiyo-e* master Nishikawa Sukenobu (1671–1750). Famed for his depictions of female figures, the artist's subtle and graceful images of rural life, Shinto ritual and haunting landscapes in this book are accompanied by examples of classical *waka* – a form of Japanese poetry from which the haiku is derived.

This volume was owned by Margaret Greville of Polesden Lacey (1863–1942), who had a fondness for Asian art and was an inveterate collector. She visited Japan and hosted Japanese dignitaries at her Surrey home, one of whom may well have presented her with this book. TP

Polesden Lacey, Surrey · Ehon Tsukubayama · *Nishikawa Sukenobu* · *Kyoto* · *c.1797* · *25.6 x 18.6cm* · *20th-century red morocco binding* · NT 3221118

Keep it local

Trust libraries often contain locally printed items less likely to survive elsewhere because they were not acquired at the time by institutional libraries. Some might be purchased in nearby market towns, others given by authors who were friends, or by those hoping for patronage. Nostell has a particularly strong collection of printing from its region, including items collected by antiquarian Charles Winn (1795–1874).

This rare anonymous novel was printed in nearby Wakefield by Elizabeth Waller (c.1746–1825) and Rowland Hurst (c.1776–1823) for a London publisher. Like many early female printers, Waller had taken over her husband's business after his death, printing books, official notices, theatre programmes and local trade material.

This copy is still stitched into its original paper wrappers. Unlike modern paperbacks, wrappers were meant to be temporary protection until buyers had the books bound in their chosen style. Some owners chose not to bind their general leisure reading, so surviving unbound publications provide invaluable evidence for students of publishing and binding history. NT

Nostell, West Yorkshire · Filial Indiscretions; or, The Female Chevalier · *Wakefield* · *1799* · *3 volumes* · *19 x 12cm* · *Duodecimo* · *Publisher's blue paper binding, stab-stitched and uncut* · *NT 3059745*

A wife's heritage

It was once said of Philip Yorke of Erddig (1743–1804) that he 'had no great respect for the mountain Welsh, great or small'. However, his attitude changed in 1782, when he married his second wife, Diana Wynne (1748–1805). She was a member of a proud Welsh family said to have descended from Marchudd, a 9th-century lord and founder of one of the ancient tribes of North Wales.

Yorke seized upon and celebrated his wife's lineage, and shortly after their marriage transformed Erddig's Billiard Room into the Tribes Room, resplendent with the coats of arms of Wales's ancient ruling families.

For the rest of his life Yorke, a long-standing member of the Society of Antiquaries, studied the genealogies of ancient Wales, the culmination of which was his book *The Royal Tribes of Wales*. This is his own copy, embellished throughout with hand-painted heraldic shields, much like the early genealogical manuscripts he pored over during his research and of which a single example survives in the library at Erddig. TP

Erddig, Wrexham · The Royal Tribes of Wales · *Philip Yorke* · Wrexham · 1799 · 27.3 x 22.2cm · 18th-century olive green morocco binding with gilt decoration · NT 3078495

ROYAL TRIBES
OF
WALES.

BY PHILIP YORKE, ESQ. OF ERTHIG.

...... et nos aliquod nomenque decusque,
Gessimus............................Virg.

Printed by John Painter.
1799.

ሢቶታቀወ፡እመኒ፡በምሳሌ፡መሩ፡እም
ሀዐሬ፡ሰልጣን፡ለየማንየ፡ይክሥት፡ሉቱ
ሰጸሔሬ፡ኖኃያት፡ለእለ፡ይዴዓሩ፡በእንተ
ፍቅሬ፡ክርስቶስ፡ሰብሐት፡ለከ፡እዘተ
ኃጋእ፡ወክሠት፡እንተ፡ለፍቁ፡ሬሪኩ፡ሰዒ
ለመ፡ዓለም፡እሚገ

ምዕራፍ፡ሸ፡ዐ፡ወሱተ፡ክበ፡ይርሰ፡በ
እንተ፡ሰሉሰ፡ቀዱሰ፡እንተ፡ይእቲ፡ሢ
ጸሬ፡አካላት፡ዘየሰግዱ፡ሳቲ፡ወተተክ
ወት፡በምሕረት፡ለሕሲና፡ባሕታዊየ
ሰብሐት፡ለንቅዓ፡ጥበብ፡ከ፡እአምሳከ
ሰብሐት፡ለፍቅሬ፡ኪንክ፡ዘየተዳዴ፡እም
እእምሬ፡ጣራን፡እንተ፡ባቲ፡ሰክራ
ወበዝሁ፡ኩሎመ፡ዓላማት፡ልዑላት
እንዘ፡ኃብ፡እተ፡ይእቲ፡እም፡ጌሆመ
ዐቅብ፡ለተርኩም፡ወእንዘ፡ፅንተ
ተሰመየተዋ፡ሃየተ፡ክኔ፡ኢየተ፡ነገር
ወተሰልስት፡ክኔ፡ኢየተሊበወ፡እሰ
መ፡ልዑል፡እንተ፡እም፡ኩሉ፡ተሰምየ
ብርኃነከ፡ቀዱሰ፡እግዚእ፡ዘእምኔሁ
ተመለእ፡ሕሊናሆመ፡ለኃየሳቲ፡ክ
ዱስ፡እለ፡ይሬእዩ፡እጽርዓ፡ጸዱሰ፡ዘ
ከ፡እግዚእ፡ለዶሰርቀ፡ሰት፡ክብሔቲ

ዘምሰጢ፡ራቲ፡ክ፡ወከተ፡ባቡ፡እት፡ሐሲና
ከመ፡ይካሰጥ፡ም፡ስዕተ፡ባቡ፡እት፡በእርቀ
በከመ፡ይደሉ፡ለደጋ፡ከ፡ከመ፡ኃየተስዓል
እንብዐ፡እም፡እንከር፡ተ፡ስን፡ከ፡ዘኢየተ
ከኃል፡በመሰሉ፡ወበነባ፡በታል፡እም
ይእዚ፡ሐማራ፡እትዬ፡ግነገር፡ከ፡በእ
ምጣን፡ኃየልን፡በእንተ፡ግብር፡ዘኢየተ
ነገር፡ከመ፡ተሰማራ፡ምንት፡ወእቱ፡እን
ዘእምን፡በእግዚ፡እብሔር፡ተዋሀ
ተ፡ሰሳሒ፡ከመዝ፡ይተ፡በሀል፡ወምንተ
ወእቱ፡ነጸሬ፡እካላት፡ከወሐነ፡እንተ
ኢተተነገር፡ግሙሬ፡እንተ፡ታሰተሪ፡ለ
ፍውራነ፡በከመ፡ይተ፡ወሀቦ፡ለዘየሬሲ
በእምጣን፡ቀየሰናሁ፡አብ፡ይሰመይ
አበ፡ወለሲሁ፡ጠባዕ፡መለከተ፡ወልዱኒ
ወመንፈሱ፡ቅዱሰ፡ሐየላቲሁ፡እሙንቱ
ወልዱኒ፡ይሰመይ፡ታሰ፡እሰመ፡ታሰ፡እእም
ርቱ፡ለእግዚእ፡ብሔር፡ወእቱ፡ወጸ
ወሉሰ፡እእምላ፡ካዊ፡ይሰምየ፡ጠበ፡በእብ
ወየበ፡እየዊ፡ሁ፡ሰረራ፡ዓለማት፡ዘወ
እቱ፡በእምርቱ፡ብሂል፡ወዓዲ፡ይሰ
መይ፡ወልዱ፡በእንተ፡ዘተፈ፡ጥወሬ፡ኩሉ
ቦቱ፡ወወተ፡ቀመ፡ሰርዓጾ፡መ፡ወእብ

Ethiopian aesthetics

This Ethiopian manuscript prayer book of the 18th or 19th century is a copy of the *Arganonä Maryam* (The Harp of Mary), a poetic work in praise of the Virgin Mary, composed in the 15th century by Giyorgis of Sägla (*c.*1365–1425). He is one of the most important Ethiopian Christian writers and produced a number of seminal texts, the best known of which is his *Maṣḥafa Məṣṭir* (Book of Mystery), which he wrote in 1424.

The manuscript was acquired by Charles Paget Wade (1883–1956), owner of Snowshill Manor, as an aesthetically pleasing curiosity to add to his vast, eclectic collection of global books, manuscripts and other artefacts. It is unlikely that Wade knew anything about the text or the author, or appreciated the ancientness of the language in which the manuscript is written. It is Ge'ez, or classical Ethiopian, which was the primary language of the Ethiopian Church, and has a history extending back to at least the 4th century. TP

Snowshill Manor, Gloucestershire · Arganonä Maryam
· *Giyorgis of Sägla · Ethiopia · c.1750–1820 · 21 x 18.9cm ·*
Original Ethiopian wooden binding · NT 3106158

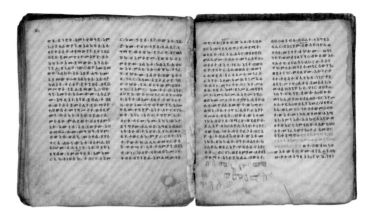

19. Aug. 1806.

25. June 1807.

10. Sep. 1807.

3. Sep. 1807.

Preserved in profile

White Watson (1760–1835) came from a family of stonemasons who worked at grand Derbyshire houses such as Chatsworth. He traded as a marble-worker and mineral dealer in Bakewell, but was known too for his geological research and belonged to several learned societies.

Watson had a sideline in producing silhouette portraits and this led to commissions from the local gentry, acquaintances and visitors such as the teenage singer Catherine Edwards (b.*c*.1793; opposite, bottom left), who had 'remarkable expanded eyebrows'. This volume may contain copies he made of his proofs for an intended history of Bakewell, as several of the portraits contain later notes about the lives or deaths of the sitters.

After Watson's own death, many of his papers were saved by his friend William Bateman (1787–1835) of nearby Middleton Hall. Bateman's library and museum of antiquities passed to his son Thomas (1823–61), well known for his archaeological excavations, whose extensive collection was sold by his heirs in 1893. NT

Kedleston Hall, Derbyshire · Profiles Executed by White Watson, Vol. II · *White Watson · Derbyshire · c.1800–33 · 17 x 10cm · 19th-century quarter leather and marbled paper binding · Bookplate of 'Bateman of Middleton Hall (by Youlgrave) in the County of Derby' · NT 3142183*

INDEX.

no.
1. The Rev. Francis Gisborne Staveley.
2. Mr Scholefield. Barlborough —
3. Mr Francis Mason. Foolow.
4. Miss Woad — Yorkshire —
5. The Rev. Peter Cunningham Eyam
6. Mr George Platt. Rotherham,
7. Thomas Barker Esqr. taken in Germany
8. The Rev. Alexr. Barker. Clown —
9. George Barker Esqr. Darley - Hall —
10. Mrs Barker. Darley. Hall —
11. Mr Brailsford — Hardwick.
12. Miss Frances Barker. Darley —
13. Miss Maria Barker - Darley —
14. Mr Joseph Gould. Bakewell now
 of Manchester —
15. Mr Hindley — Manchester —
16. Mr Charles Pasmore. Doncaster.
17. Mr Danl Dakeyne junr Enab.house
18. Mr Joseph Wilson - Crown & anchor.
19. Mr Pope. from Jamaica —
20. Doctor Stoncliffe —

Popular tales and songs

Chapbooks were pocket-sized popular works sold by travelling dealers (chapmen), who would sell them with other desirable items at fairs, markets or door to door. The contents ranged from popular folklore and fables to moral or bawdy tales, popular verse and riddles. Others carried more up-to-the minute tales of 'true crime', with accounts of the confessions and executions of highwaymen and murderers.

They were generally produced very cheaply on poor-quality paper, sometimes pirated, and often illustrated with crude woodcuts that were reused many times to keep costs down, whether appropriate to the text or not.

Since this form of popular literature was cheaply made and not meant to last, chapbooks are now extremely rare. Townend's collection includes unique survivals, most published in the north of England and Scotland in the late 18th and early 19th centuries.

This songbook is a typical example, printed in nearby Penrith by bookseller Ann Bell (d.1823) and bound with 26 similar books of songs and poems published in nine towns and cities, ranging from Doncaster in the West Riding (now South Yorkshire) to Stirling in central Scotland. NT

Townend, Cumbria · A Collection of New Songs · *Penrith · c.1800 · 15.9 x 9.6cm · Octavo · 19th-century quarter leather and marbled paper binding · NT 3074577.11*

A children's library

Portable miniature libraries are known to have existed since the 16th century. This one, with a box decorated to look like a miniature bookcase, is unusual in being specifically for children. A full-sized bookcase in the library at A La Ronde contains the other normal-sized and miniature books, shells, bead-work and assorted objects belonging to cousins Jane Parminter (1750–1811) and Mary Parminter (1767–1849).

Books written and made in smaller formats specifically for children to read themselves became much more common after 1750. Before that date, children's books tended to be mainly alphabets, school books or juvenile religious texts. After 1750, the growth of road networks led to the establishment of more provincial printing houses and newspapers, so books too became cheaper and more easily available.

From the second half of the 18th century, publishers began to advertise books intended for children's amusement, as well as for their instruction. This miniature library is one of the more luxurious examples in what was a growth area for publishing. YL

A La Ronde, Devon · The Miniature Library · *London · c.1800 · Box: 31.5 x 18cm · Decorated box containing individually bound miniature volumes · Probably bought new by or for Jane and Mary Parminter · NT 1312597.1–.32*

It has already been said that it is not meant to arrange the colours in circles in a Picture, for besides the absurdity of that, the proper quantity of each could not be observed as may be seen here, if each circle was filled with its own colour. Therefore nothing more must be looked for in this than the proper situation for each colour in respect to the others, which is shewn by the small portion that is coloured, and if the effect of Light & Shade on a Ball and concave object is considered, it may be known directly what degree of brilliancy or shade should be given to each colour in every different part of it. This Idea will be of use if kept in mind when Painting Objects from nature.

Published at the Art Libraria Nov.r 1, 1804, by T Gardiner Princes Street Cavendish Square.

A splash of colour

The first publication by Mary Gartside (c.1755–1819), who worked as a teacher and botanical artist, was this essay – part practical painting manual for her pupils and part theoretical treatise. It is also the earliest-known theory of colour by a woman, although she hid her gender by publishing as 'M. Gartside', perhaps to ensure her work was taken seriously.

The plates, mostly coloured by hand, illustrate her instructions and ideas, showing how to combine contrasting and harmonising tints. Her striking watercolour 'blots', presented as a guide to colouring groups of flowers, have been compared to abstract art. Although her work has become more widely recognised in recent years, little is known of Gartside's life. However, she exhibited at the Royal Academy and seems to have been an active member of London's artistic and intellectual circles. She also had links with Manchester, and this book was dedicated to Lady Sophia Grey (1777–1849), whose family owned nearby Dunham Massey. NT

Tatton Park, Cheshire · An Essay on Light and Shade, on Colours, and on Composition in General · *Mary Gartside* · *London* · *1805* · *29 x 22.5cm* · *Quarto* · *Book label of Wilbraham Egerton of Tatton (1781-1856)* · *Publisher's binding, grey paper boards, uncut and largely unopened* · *NT 3068303* · *‡ 1960*

AN ESSAY ON Light and Shade ON Colours and on COMPOSITION IN GENERAL:

BY Mr. Burnside

"Return fair Colouring!" Claude Lorrain Esq.
What Sums content thee, and what Giaovanberg. Du Fresnoy

LONDON.
Printed for the Author, by J.B. Amand, White Friars,
And Sold by
J. Gardiner, Bookseller, Princes Street, Cavendish Square.
1805.

39
TABLE I.
Primatic Colours.

Elementary ones. Compounds.

48 Yellow

45 Red

48 Yellow 45 Red compose Orange

80 Violet

80 Violet 60 Blue compose Indigo

48 Yellow 60 Blue compose Green

60 Blue

These colours, with the addition of White, to lighten, and Black, to darken, belong to the *first rank*, or most prominent part of a group, and have no place in any other part of it.

41
TABLE II.
Compound Tints of a second Order, composed from the pure Primatic Compounds.

Prismatic Orange and Green compose Yellow . of a second order.

Prismatic Indigo and Green compose Blue . of a second order.

Prismatic Orange and Violet compose Red . of a second order.

The above three colours compose the four following:

Red and Blue compose Violet . of a second order.

Red and Yellow compose Orange . of a second order.

Red and Blue compose Indigo . of a second order.

Yellow and Blue compose Green . of a second order.

(White? 1.)

(Yellow? 2.)

(Crimson 3.)

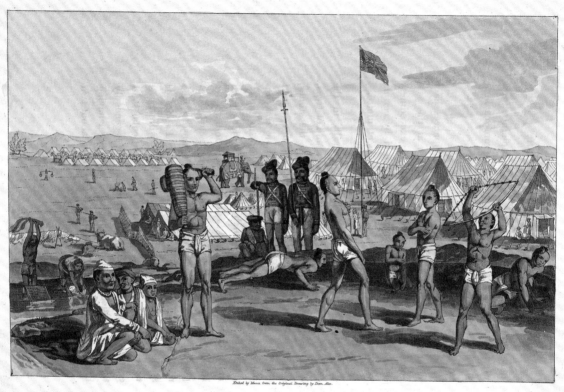

Etched by Meaza from the Original Drawing by Dan. Alto.

An Ukhara, with a view of the British Resident's Camp.

Published April 5, 1815, by J. Murray, Albemarle Street.

An army on the move

The Marathas originate in the Maharashtra area of India. Many Marathas became soldiers, and the Maratha Empire was a dominant force on the Indian subcontinent in the 18th century, allying with the English East India Company in the 1790s. Captain (later Colonel) Thomas Broughton (1778–1835) was appointed the Company's military resident with the Marathas in 1802, and wrote this account as letters to his brother while travelling with the camp of Daulat Rao Sindhia (1779–1827), Maharaja of Gwalior, during a campaign.

Broughton's description of the Marathas' 'character, manners, domestic habits and religious ceremonies' for a European audience includes accounts of marches and battles, alongside descriptions of daily life for both men and women, including the various entertainments and sports enjoyed by camp residents. It was illustrated with ten hand-coloured plates drawn by Indian artist Deen Alee (active 1809) and then engraved in London by English artists John Augustus Atkinson (c.1775–1830) and Thomas Baxter (1782–1821). Shown here are 'Playing the Hohlee', which depicts the Hindu festival of Holi, where coloured powder is thrown in celebration, and 'An Ukhara', which shows strengthening exercises undertaken by soldiers on the wrestling ground. NT

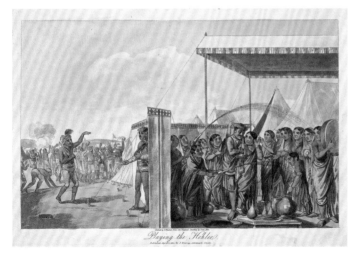

Playing the Hohlee.

Calke Abbey, Derbyshire · Letters Written in a Mahratta Camp During the Year 1809 · *Thomas Duer Broughton* · *London* · *1813* · *29 x 23cm* · *Quarto* · *Publisher's binding, brown paper boards with printed paper spine label* · *NT 3153793 · ‡ 1985*

A profusion of pamphlets

Charles Winn (1795–1874) transformed Nostell's library, converting the Billiard Room to hold his many purchases; it now contains more books than the 18th-century Library designed by Robert Adam (1728–92). Winn's largest single purchase was the collection of William Robert Hay (1761–1839), rector of nearby Ackworth. The 2,800 pamphlets (bound into 320 volumes) cover a wide range of subjects including religion, wars with America and France, politics, local government, and agriculture.

A typical pamphlet, this eyewitness account of the Peterloo Massacre on 16 August 1819 would have been of personal interest to Hay, the chairman of the Salford magistrates who had called in the Yeomanry Cavalry to arrest speakers at the meeting. The author, a cotton manufacturer, defended the actions of the authorities and recorded that Hay personally escorted the radical speaker Henry Hunt (1773–1835) away from the gathering after the infamous cavalry charge. NT

Nostell, West Yorkshire · An Exposure of the Calumnies Circulated · Francis Philips · London · 1819 · 22 x 14cm · Octavo · 19th-century sheep binding · Armorial bookplate of William Robert Hay; after Hay's death the pamphlets were bought by York bookseller Alexander Barclay, who sold them to Charles Winn · NT 3020322.10

DIVINITY TRACTS

73

TRACTS

GEO. III.
CX.

PAMPHLETS

POLITICAL TRACTS.

STRICKLAND
ON CORN LAWS.

RATES OF THE
AIRE & CALDER.

CREEVEY'S LETT.
TO
LD. J. RUSSELL

LD. STOWRTON
ON
ABSENTEEISM

LINGARDS
VINDICATION

ALLEN'S
REPLY.

ATKINSON
ON FREE TRADE

TRACTS

LORD PETRE
HIPPISLEY
CANNING.
CATH: ASSOC:
CATH: VIND:
ON COMMUNIT:
WESTERN.
WILLIAMS TRIAL
ON POLICE 1816

TRACTS
ON THE
CATHOLIC
QUESTION

APOLOGY
FOR THE
CATHOLICS
LINGARD'S
REMARKS

LINGARD'S
REVIEW.
EUSTACE'S
ANSWER TO
POP LINCOLN

NUGENT'S
LETTER

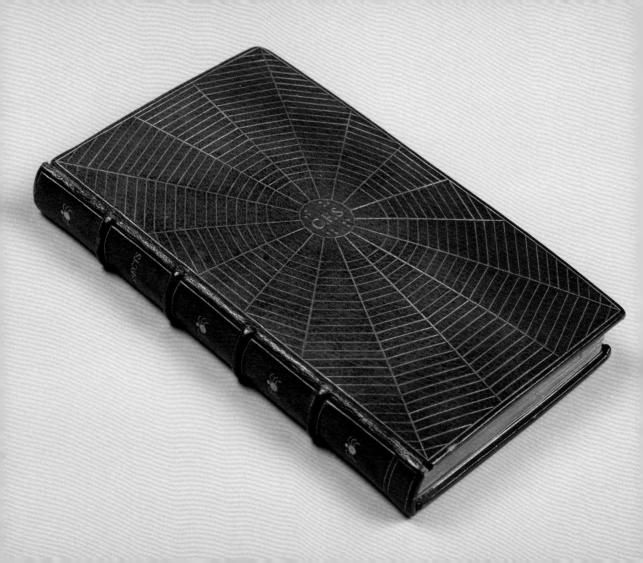

Fantastic beasts

This delightful little book – a history of common insects – is one of the few to include the signature of Charlotte Shaw, née Payne-Townshend (1857–1943), the wife of George Bernard Shaw (1856–1950). Bought for her second-hand, probably in Ireland where it was printed, it was rebound by one of the 20th-century's finest binders. It had lost its title page, but kept the frontispiece illustration of a large garden spider, on which the binding was modelled.

George Bernard Shaw's inscription records the rediscovery of his wife's book in 1937. It was mended and rebound by Douglas Cockerell (1870–1945) in his workshop at Letchworth, Hertfordshire. Cockerell had trained under T.J. Cobden-Sanderson (1840–1922) at the famous Doves Bindery in Hammersmith, London. A friend of William Morris (1834–96) and his wife Jane Burden (1839–1914), Cobden-Sanderson was involved in the founding of the Arts and Crafts movement.

After completing his apprenticeship, Cockerell set up a workshop, initially in London. He taught at several London schools of art and crafts while experimenting with materials and techniques. True to Arts and Crafts philosophy, his rebinding of Charlotte's insect book is both practical and beautiful. Both covers feature Cockerell's spider's web design, and the spine is stamped with a spider motif. YL

Shaw's Corner, Hertfordshire · The Natural History of Remarkable Insects · *Dublin* · *1822?* · *14 x 9cm* · *1930s brown morocco, gold tooling; binding stamped by Douglas Cockerell: D.C. & Son 1938 · Inscriptions include: C.F. Payne-Townshend · NT 3061859*

The royal treatment

Born in Patna, capital of Bihar in India, Deen Mahomed (1759–1851) spent several years in the Bengal Army before emigrating to Ireland in 1784, where he published a pioneering account of his travels. By 1807 he was in London, where he opened a steam bath offering 'shampooing' (therapeutic body massage), and also established the Hindostanee Coffee House, the first Indian restaurant in England.

After these businesses failed, Mahomed moved to the fashionable resort of Brighton and opened a bath house on the Steyne, a square near the Royal Pavilion. He then went on to build impressive seafront premises called Mahomed's Baths (right). The business became very successful, gaining him a royal warrant as shampooing surgeon to George IV (1762–1830).

Mahomed published this book about shampooing – essentially an extended advertisement – with testimonials from satisfied customers and descriptions of the cures he could offer for problems such as rheumatism, asthma and paralysis. The list of subscribers shows how fashionable these massages had become, and includes the 6th Duke of Devonshire (1790–1858), who owned this copy. Further evidence of the duke's patronage survives in the form of an advertising card (NT 3130828.3.2) used elsewhere as a bookmark. NT

Hardwick Hall, Derbyshire · Shampooing; or, Benefits Resulting from the Use of the Indian Medicated Vapour Bath · *Deen Mahomed · Brighton · 1826 · 21.5 x 14cm · 19th-century red morocco binding with a contemporary advertisement for 'Cupping. Mr. Mahomed, Jun.' pasted inside the front board · William Spencer Cavendish, 6th Duke of Devonshire · NT 3161994 · ‡ 1958*

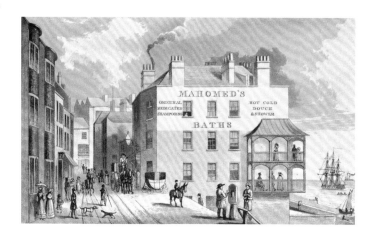

S. D. Mahomed,

Shampooing Surgeon,

BRIGHTON.

Published June 1822, by J. Cordwell, at his Repository, 20 Great East-Street, Brighton.

SHAMPOOING;

OR,

BENEFITS RESULTING FROM

THE USE OF

THE INDIAN

MEDICATED VAPOUR BATH,

As introduced into this Country,

BY

S. D. MAHOMED,

(*A Native of India*)

CONTAINING A BRIEF BUT COMPREHENSIVE VIEW OF THE

EFFECTS PRODUCED BY THE USE OF

THE WARM BATH,

IN COMPARISON WITH

STEAM OR VAPOUR BATHING.

ALSO

A detailed account of the various Cases to which this healing remedy may be applied ; its general efficacy in peculiar diseases, and its success in innumerable instances, when all other remedies had been ineffectual.

TO WHICH IS SUBJOINED

AN ALPHABETICAL LIST OF NAMES

(Many of the very first consequence,)

Subscribed in testimony of the important use & general approval

OF

THE INDIAN METHOD OF SHAMPOOING.

(Second Edition.)

BRIGHTON :

PRINTED BY CREASY AND BAKER, GAZETTE-OFFICE, NORTH-STREET.

1826.

PYRAMIDS
of
GEEZEH.
BY
J. G. WILKINSON Esqr.
1826.

Village of e' Rôzza
or el Byrât

Stone Causeway
repaired by the Caliphs

inclined Causeway

Stone Causeway

An early Egyptologist

The scholar John Gardner Wilkinson (1797–1875) travelled to Egypt in 1821 and spent 12 years excavating, drawing and researching, at one point living in an ancient tomb at Thebes. After returning to England, he published several books and articles on Egypt, receiving a knighthood in 1839 for his work, which included the numbering system for tombs in the Valley of the Kings.

This plan of Giza is taken from Wilkinson's *Topographical Survey of Thebes* and holds fascinating evidence of contemporary excavations. He has made handwritten annotations, including a lift-up flap showing amendments around the Great Sphinx as he recorded discoveries, and a manuscript sheet of drawings of the graves. A copy of the full map (NT 3046176) has no flap or annotations around the Sphinx – shown here in the smaller image – but does have similar manuscript additions for Thebes.

Wilkinson built up a network of research contacts across Europe who were working on a wide variety of subjects and this is reflected in his extensive library. He left his books and papers to relatives at Calke Abbey rather than an academic institution, and this perhaps explains why Wilkinson was largely forgotten until recent years, despite his early influence on British Egyptology. NT

Calke Abbey, Derbyshire · Pyramids of Geezeh · *Sir John Gardner Wilkinson · London · 1830 · 84 x 52cm · Ink on paper; dissected and mounted on cloth, blue cloth cover · Bequeathed to Sir John Harpur Crewe, 9th Baronet (1824–86), husband of Wilkinson's cousin Georgiana Stanhope Lovell (1824–1910) · NT 3227357 · ‡ 1985*

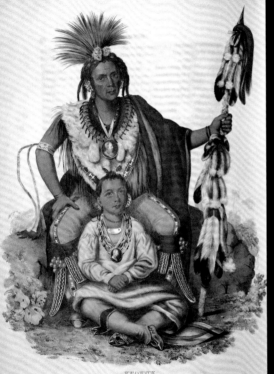

KEOKUK
CHIEF OF THE SACS & FOXES

PUBLISHED BY F. W. GREENOUGH, PHILADA.

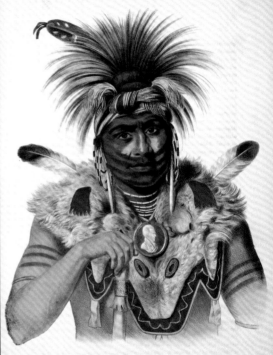

NE SOU A QUOIT
A FOX CHIEF.

PUBLISHED BY F. W. GREENOUGH, PHILADA.

A unique record

This monumental early American lithographic publication was one of the most splendid and visually stunning of its time. Decades in production, it was sold by subscription, and in the process bankrupted two of its four successive publishers.

After service in the war of 1812, Thomas Loraine McKenney (1785–1859), who co-wrote the book with James Hall (1793–1868), went on to become Superintendent of Indian Trade, then head of the new Bureau of Indian Affairs. Although McKenney became increasingly interested in Native American culture and amassed a museum collection and a gallery that was opened to the public, he was also the architect of the 1830 Removal Act, which authorised the forcible relocation of Indigenous peoples in the Eastern states.

Charles Bird King (1785–1844) produced portraits in oil of the Native American chiefs who went to Washington DC for the treaty negotiations. These were supplemented in the publication with likenesses sent from the Indian Territories and biographies written by McKenney and Hall.

The chiefs shown in these two portraits (opposite) are identified as 'Ne-Sou-a-Quoit, A Fox Chief' and 'Keokuk, Chief of the Sacs & Foxes'. The Sauk (Sacs) and Meskwaki (Fox) peoples have been closely allied since the early 18th century, and speak closely related Algonquian languages.

Planned as a 20-part series, each part containing six portraits, *History of the Indian Tribes of North America* is the only surviving record of McKenney's collection of around 200 portraits of Native Americans. Sadly, they were all destroyed by fire at the Smithsonian Institution Building in 1865. Cheaper reprints have never been able to match the quality of the original publication. YL

Anglesey Abbey, Cambridgeshire · History of the Indian Tribes of North America · *Thomas Loraine McKenney and James Hall · Philadelphia · 1838–44 · 51 x 37.2cm · 20th-century morocco binding · NT 3127404*

Transcendental treasure

The very faint pencil inscription on the flyleaf of this book arguably provides it with the most important US association of any National Trust book. It was presented to Henry David Thoreau (1817–62) by Ralph Waldo Emerson (1803–82), two of the most prominent 19th-century American writers, and leading figures in the philosophical movement known as transcendentalism. Both were greatly influenced by the Scottish writer Thomas Carlyle (1795–1881), through whom they were introduced to European philosophers, and it is the first American edition of Carlyle's *Past and Present* that has been inscribed. Emerson, who visited Carlyle at his Chelsea home, edited the Boston edition of the book – a critical comparison between medieval and 19th-century England.

It may well be that this book accompanied Thoreau during the most famous period of his life: his experiment in simple living on the edge of Walden Pond, near Concord, Massachusetts, between 1845 and 1847. It was in his lakeside house that he wrote a celebratory essay on Carlyle, describing *Past and Present* as 'at once idyllic, narrative, heroic; a beautiful restoration of a past age'. TP

Carlyle's House, London · Past and Present · *Thomas Carlyle* · Boston · *1843* · *20 x 13cm* · *Publisher's printed paper binding* · *Inscribed: 'Henry D. Thoreau from R.W.E.'* · *Given to Carlyle's House by Charles E. Goodspeed* · *NT 3013842*

Right · Thomas Carlyle (1795–1881), the author of
Past and Present, in a photograph by Elliott & Fry
of 1865 (NT 263681).

Oversized orchids

A masterpiece of Victorian garden design, Biddulph Grange in Staffordshire was created by James Bateman (1811–97) to house his collection of plants from around the world. His passion for exotics led him into botanical publishing, the pinnacle of which is his epic book on Mexican and Guatemalan orchids.

Published in London in 1843 in a limited edition of 125 copies, Bateman's *Orchidaceæ* is the largest and, arguably, the finest orchid book ever produced. The 40 life-size, hand-coloured lithographic plates were created predominantly from designs by two botanical artists, Sarah Drake (1803–57) and Augusta Withers (1792–1877). They are accompanied by two humorous vignettes by the famous caricaturist George Cruikshank (1792–1878).

This copy is from the library at Tatton Park, the former home of Wilbraham Egerton (1781–1856), who is listed as one of the book's subscribers. Bateman may have been acquainted with Tatton through his marriage to Maria Egerton (1812–95), a distant member of the extended Egerton family. TP

Tatton Park, Cheshire · The Orchidaceæ of Mexico and Guatemala · *James Bateman* · *London* · *1843* · *72.6 x 53.1cm* · *19th-century half calf and green cloth binding* · *NT 3072701* · *‡ 1960*

NOBRALIA NACRANTHA.

A well-worn travel guide

A rare practical guide to 1850s' India, this book can be found as one large volume, as in this case, or two smaller ones. Such travel guides tended to be well used, so few copies survive. In addition, those bound in two volumes are often missing one of them. Originally intended to be 250 pages long, the handbook took eight years to complete and has nearly 1,000 pages.

Written for an English audience and published at a time when India was still under the rule of the East India Company, the book's chapters cover topics such as culture, language, religions, coinage and mythology. It also includes guidance on what clothes to pack, first aid in a tropical climate and even how to deal with snakebites. The wide-ranging contents are similar to those found in present-day guidebooks, although the latter tend to be more generously illustrated.

Over half of the handbook is devoted to useful phrases and vocabulary. Much space is taken up by regional variations of words, though the compiler suggests taking lessons or employing an interpreter. In two-volume editions, the vocabulary section was often bound as the second volume, but no examples survive, possibly because of heavy use.

The writer Rudyard Kipling (1865–1936), who spent many years in India, picked up his copy second-hand, possibly on a return journey to the country in the 1880s. YL

Bateman's, East Sussex · The Anglo-Hindoostanee Hand-book, or, Stranger's Self-Interpreter and Guide · *London and Calcutta · 1850 · 18.6 x 12cm · Publisher's cloth binding · Pictorial bookplate: 'Ex Libris Rudyard Kipling AD1894' · NT 3069696*

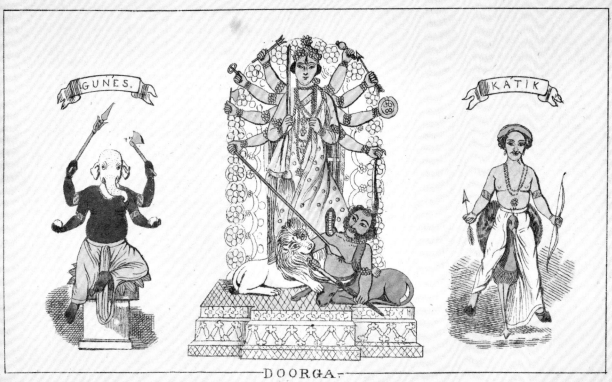

GUNÉS. KATIK.

DOORGA.

From Coleman's "Mythology of the Hindoos."

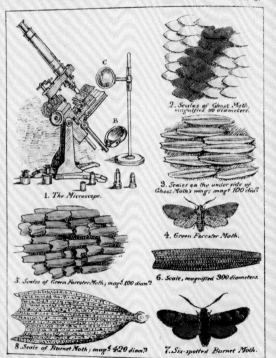

1. The Microscope.

2. Scales of Ghost Moth, magnified 90 diameters.

3. Scales on the under side of Ghost Moth's wing; mag.^d 100 diam.^rs

4. Green Forester Moth.

5. Scales of Green Forester Moth; mag.^d 100 diam.^rs

6. Scale, magnified 300 diameters.

7. Six-spotted Burnet Moth.

8. Scale of Burnet Moth; mag.^d 420 diam.^rs

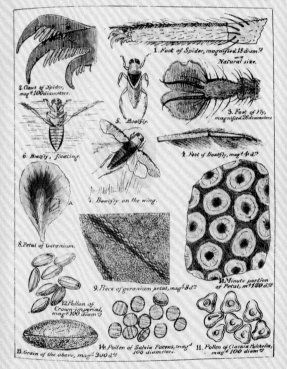

1. Foot of Spider, magnified 18 diam.^rs Natural size.

2. Claws of Spider, mag.^d 100 diameters.

3. Foot of Fly, magnified 20 diameters.

4. Foot of Boatfly, mag.^d 4 d.^rs

5. Boatfly.

6. Boatfly, floating.

7. Boatfly on the wing.

8. Petal of Geranium.

9. Piece of geranium petal, mag.^d 8 d.^rs

10. Minute portion of Petal, m.^d 150 d.^rs

11. Pollen of Clarkia Pulchella, mag.^d 100 diam.^rs

12. Pollen of Crown imperial, mag.^d 100 diam.^rs

13. Grain of the above, mag.^d 300 d.^rs

14. Pollen of Salvia Patens, mag.^d 100 diameters.

Scientific trailblazer

For Mary Ward (1827–69), observing the world through scientific instruments was the joy of her short life. She was fortunate to have encouraging parents, who procured a powerful microscope for her 18th birthday, and to be cousins with William Parsons, 3rd Earl of Rosse (1800–67), whose telescope, the 'Leviathan of Parsonstown', was the largest in the world and available for her to use.

Her accurate observations were revered by others in the scientific community, but it was Ward's gift for sharing her findings that set her apart. Her various books, written primarily for children, are infectious in their enthusiasm, particularly when accompanied by her own illustrations – as is the case with this volume, her now-rare first book, printed locally in 1857 in an edition of 250 copies.

Following her death – one of the earliest recorded automobile fatalities – her husband, the 5th Viscount Bangor (1828–1911), took her library and microscopic equipment to Castle Ward, where they remain today as a testament to a pioneering female scientist. TP

Castle Ward, County Down · Sketches with the Microscope · *Mary Ward · Parsonstown · 1857 · 15.9 x 12.5cm · Publisher's blue cloth binding · Ownership inscription of Somerset Henry Maxwell, 10th Baron Farnham (1849–1900) · NT 3082063*

AMERICA.

ASSASSINATION OF PRESIDENT LINCOLN.

14th of April 1865

OFFICIAL REPORT.

The following official telegram from Mr. Secretary Stanton has been received by the United States' Legation in London:—

(*Viâ* GREENCASTLE, per NOVA SCOTIAN.)

"Sir,—It has become my distressing duty to announce to you that last night his Excellency Abraham Lincoln, President of the United States, was assassinated, about the hour of half-past 10 o'clock, in his private box at Ford's Theatre, in the city. The President about 8 o'clock accompanied Mrs. Lincoln to the theatre. Another lady and gentleman were with them in the box. About half-past 10, during a pause in the performance, the assassin entered the box, the door of which was unguarded, hastily approached the President from behind, and discharged a pistol at his head. The bullet entered the back of his head and penetrated nearly through. The assassin then leaped from the box upon the stage, brandishing a large knife or dagger, and exclaiming ' *Sic semper tyrannis!*' and escaped in the rear of the theatre. Immediately upon the discharge the President fell to the floor insensible, and continued in that state until 20 minutes past 7 o'clock this morning, when he breathed his last. About the same time the murder was being committed at the theatre another assassin presented himself at the door of Mr. Seward's residence, gained admission by representing he had a prescription from Mr. Seward's physician which he was directed to see administered, and hurried up to the third story chamber, where Mr. Seward was lying. He here discovered Mr. Frederick Seward, struck him over the head, inflicting several wounds, and fracturing the skull in two places, inflicting, it is feared, mortal wounds. He then rushed into the room where Mr. Seward was in bed, attended by a young daughter and a male nurse. The male attendant was stabbed through the lungs, and it is believed will die. The assassin then struck Mr. Seward with a knife or dagger twice in the throat and twice in the face, inflicting terrible wounds. By this time Major Seward, eldest son of the Secretary, and another attendant reached the room, and rushed to the rescue of the Secretary; they were also wounded in the conflict, and the assassin escaped. No artery or important blood-vessel was severed by any of the wounds inflicted upon him, but he was for a long time insensible from the

him. Public notice had been given that he and General Grant would be present at the theatre, and the opportunity of adding the Lieutenant-General to the number of victims to be murdered was no doubt seized for the fitting occasion of executing the plans that appear to have been in preparation for some weeks, but General Grant was compelled to be absent, and thus escaped the designs upon him. It is needless for me to say anything in regard of the influence which this atrocious murder of the President may exercise upon the affairs of this country; but I will only add that, horrible as are the atrocities that have been resorted to by the enemies of the country, they are not likely in any degree to impair the public spirit or postpone the complete and final overthrow of the rebellion. In profound grief for the events which it has become my duty to communicate to you, I have the honour to be

"Very respectfully, your obedient servant,

"EDWIN M. STANTON."

STUDY OF THE SCLAVONIC LANGUAGES.—Mr Henry Frampton, one of the executors of the late Earl of Ilchester, has addressed the following note to the editor of the *Pall Mall Gazette*:—

"Sir,—In the *Pall Mall Gazette* of the 7th inst. is a paragraph in which it is stated that the late Lord Carlisle was believed to have left the sum of £1000 for the foundation of a scholarship for the study of the Sclavonian language. Lord Carlisle may have done so, but I think it right you should be informed that William Thomas Horner, the late Earl of Ilchester, left to the Chancellor, masters, and scholars of the University of Oxford the sum of £1000 to found an exhibition lectureship or scholarship or periodical prize for the study of the Polish and other Sclavonic languages, literature, and history.' This legacy the Chancellor of the University of Oxford was duly informed of soon after his death in January 1865, but nothing further has been heard from them."

ENTIRELY ORIGINAL.—The following is a copy of a bill sent in to a gentleman a short time ago. We leave our readers to fathom the puzzle:—

| | | | | |
|---|---|---|---|---|
| Aosafada | .. | .. | .. | 3s. 6d. |
| Atakinonimomagin | .. | .. | 6d. |
| | Pade. | | | 4s. 0d. |

Drawn & Eng.ᵈ by W. Banks, Edin.ʳ

CASTLE CAMPBELL.

UNFORTUNATE DAYS.—On the 14th of April, Orsini, Charlotte Corday, Ravillac, and Booth, committed their crimes; and William III., Anne, George I., George II., George III., George IV., William IV., Washington, and President Lincoln, have all died on a Saturday.

MIXED METAPHOR.—The following specimen of this failing is taken from the *Washington Star*:—"The apple of discord is now f(?)...

MUTINY IN THE NORWICH MONASTERY.—During the absence of Brother Ignatius in the metropolis there have been serious disturbances among the brethren of the English order of St Benedict, at Norwich, and the members of the third order established in connection with it. One of the monks has issued an "Appeal to Public Opinion," in which he says:—"Mr Lyne has been gradually Romanising the ritual, and ruling in the most arbitrary manner, so that while professing to carry out the rule of St Benedict he has carried out only his own, which

Snapshots at Lacock

In the summer of 1835, William Henry Fox Talbot (1800–77) created the world's first photographic negative at his home, Lacock Abbey. Although his daughters Ela (1836–93) and Rosamond (1837–1906) did not witness this event, their portraits are among the earliest images taken by their father, and they grew up surrounded by his photographic experiments.

Lacock Abbey - Wiltshire

Twenty years after Talbot's breakthrough, which proved to be a key step in the invention of photography, one or both of the sisters began compiling this scrapbook. Beginning in August 1855 and continuing until 1872, it is full of the usual assortment of newspaper clippings and paper ephemera, but it is the volume's photographic elements that are most intriguing. These include paperwork concerning their father's contribution to the 1867 World's Fair in Paris, and six small albumen prints of historic sites in Scotland and Wiltshire, including an otherwise unrecorded image of the east front of Lacock Abbey (left). The origin of the photographs is unknown, but it is tantalising to think that they may have been taken by one of the sisters. TP

Lacock Abbey and Fox Talbot Museum, Wiltshire ·
Scrapbook Compiled by Ela Talbot or Rosamond Talbot ·
Lacock · 1855–72 · 29 x 23cm · 19th-century half leather and marbled paper binding · NT 3033744

Y MEDDYG ANIFEILIAID.

AM ANIFEILIAID CORNIOG.

Y MATH hwn o greaduriaid yn ein gwlad ni (heb fyned i son am rywogaethau o'r un natur sydd mewn gwledydd eraill), sydd yn ol eu graddau tan yr enwau a ganlyn:—Buchod, Lloiau neu Lloi, Deunawiaid, Aneiriaid neu *Heffrod*, Bustych neu Ychain.

Fe allai y bydd yn dda gan rai gael ychydig adroddiad am ddull rhai iach, a buddiol; nid af i ddywedyd am fuddioldeb y rhyw hwn, y cynnyrch penaf, a'r ffon gryfaf at gynnaliaeth ein gwlad.

AM FUCHOD.

Buchod buddiol ac iachus sydd o ddau fath; un math yn fuddiolach i ddefnyddio eu llaeth i wneyd caws ac ymenyn; y math arall i fagu Lloi, at gael bustych, a phob math o rai gwerthadwy, er elw a chynnaliaeth i'r rhai a fyddo yn eu trin. Y buchod a gyfrifir oreu at y llaethdy (*dairy*), a fydd i ryw radd yn rhywiocach na rhai at godi stôr (*stock*) oddiwrthynt; er hyny, mae tebygoliaeth yn y ddau fath i'w gilydd, mewn llawer o bethau, os byddant yn iach a chryfion. Cyfrifir rhai cochion, braith, a gwineuon yn fwy llaethog na rhai duon a brychion. Gellwch adnabod buwch yn lled hawdd wrth olwg lawen fwynaidd a fo arni; ei phen yn gymhwys o uchder at ei chorph, ei chyrn yn sefyll yn hardd a gwynion, yn codi o'i phen ymhell o'diwrth eu gilydd; trum uchel rhwng y ddau gorn a'i gilydd; y talcen yn llydan a gwastad; ei llygaid yn dduon, mawr a bywiog; ei thrwyn yn addfain, ac heb fod yn rhy hir; ei ffroenau yn lled fawrion a theneu oddiarnynt; teispen ei thrwyn yn llydan, iachus a gwlithog; ei gweflau a'i safn yn llydan a hardd; * ei chlustiau yn chwarëus, ac yn fawr a garw ei blew; ei gwddf yn addfain a go hir; ei thagell yn deneu a rhywiogaidd, yn cyrhaedd o

* Cofier bod hyn wedi ei ysgrifenu er's 48 o flynyddoedd.

The Welsh animal doctor

Aside from the family Bible, this volume – *Y Meddyg Anifeiliaid* (The Animal Doctor) – was probably the most treasured of the few books owned by the Roberts family of Ty'n-y-Coed Uchaf, a small farm in Snowdonia. Indispensable for the remote smallholder, the book provides advice on identifying ailments in animals and the techniques for administering medicines, some of which are illustrated by the prominent London lithographer William Dickes (1815–92).

Veterinary medicine was not the primary occupation of the book's author, John Edwards (1755–1823). He was a Methodist preacher, poet and farmer, who first published his layman's guide to animal health in 1816. Issued in numerous editions over the following 50 years by his son and grandson, both also named John Edwards, it became one of the most ubiquitous Welsh-language books of the 19th century. It is, therefore, no surprise to find this lovingly used copy in the National Trust's only book collection from a house where English was not the first language. TP

Ty'n-y-Coed Uchaf, Conwy · Y Meddyg Anifeiliaid · *John Edwards* · *Wrexham* · *c.1865* · *19 x 13cm* · *Publisher's quarter red morocco and green cloth binding* · *NT 3048454*

Y dull goreu o roddi diodydd meddygol i'r ych.

Alice's Abenteuer

im Wunderland

von

Lewis Carroll.

Aebersetzt von Antonie Zimmermann.

———

Mit zweiundvierzig Illustrationen

von

John Tenniel.

London:

Macmillan und Comp.

1869.

Sharing Wunderland

Few books in the National Trust's collections have as clear a line of continuous and illustrious ownership as this copy of the first German translation of *Alice's Adventures in Wonderland*. Lewis Carroll (1832–98), whose inscription is the first on the half-title page (right), took an active role in the early translations of his 1865 masterpiece – the German edition was the first to appear, quickly followed by the French. Satisfied with the quality of the printing, Carroll presented the book to its famous illustrator, John Tenniel (1820–1914), who passed it on to John Fletcher Moulton (later Lord Moulton, 1844–1921) in 1898. Ownership was then transferred to his son, followed by his step-daughter, Elsie Grahame (1862–1946), who presented it to her brother, Lord Courtauld-Thomson (1866–1954).

Grahame's playful relationship with Tenniel is the backbone of the provenance and the reason for the book entering the Trust's collections. And as the wife of Kenneth Grahame (1859–1932), the author of *The Wind in the Willows*, she provides a link between two of the greatest works of British children's literature. TP

Dorneywood House, Buckinghamshire · *Alice's Abenteuer im Wunderland* · *Lewis Carroll, trans. Antonie Zimmermann* · *London* · *1869* · *19 x 13.4cm* · *Publisher's green cloth binding* · *NT 3225786*

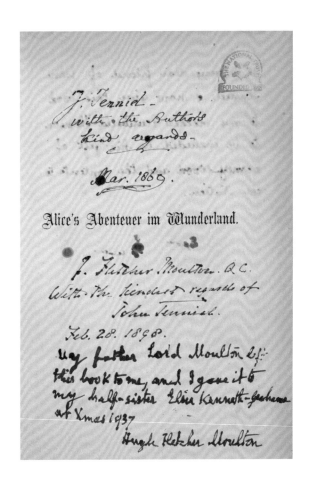

A much-loved children's library

The printed label 'Children's Library, Wallington' appears in around 60 books. Although some books with this label were published as early as 1834, its use started later – probably for the children and grandchildren of Sir George Otto Trevelyan (1838–1928), who inherited Wallington in 1886 – and continued up to the 1930s. The books are still in their original bindings, some beautifully illustrated, and markings give evidence of them being read and re-read.

Little Arthur's History of England contains notes dated from March 1875 to April 1876 that mark passages to be skipped when reading aloud, suggesting that the book was read to a child by Charles Edward Trevelyan (1807–86). In 1881 it was signed by 'Georgie', probably the young George Macaulay Trevelyan (1876–1962), who later became a respected historian. Was it this book that sparked his love of history?

During the Second World War, the collection was used by evacuees from Newcastle, along with around 50 newer books marked 'Children's Library Wallington School 1941'. NT

Wallington, Northumberland · Little Arthur's History of England · *Maria Dundas, Lady Callcott (1788–1842)* · *London · 1875 · 16.5 x 11cm · Publisher's brown cloth binding · Book label of the Children's Library, Wallington · NT 3094563*

THE
BY
E.V. LUCAS

WELLS GARD-
NER DARTON
& CO. LTD.

TWO THOUSAND
YEARS AGO
PROFESSOR CHURCH

BLACKIE & SON

STORIES
TOLD
TO A
CHILD

Jean Ingelow

GARDNER
DARTON & CO

FROM
POWDER
MONKEY
TO
ADMIRAL

W. H. G. Kingston

HODDER & STOUGHTON

THE
BOY HUNTERS
BY
CAPT MAYNE REID

ILLUSTRATED BY HARVEY

ROYAL
VISIT

TO

CRAGSIDE,
AUGUST, 1884.

Remembering a royal visit

The Newcastle engineer and industrialist
Sir William Armstrong (1810–1900) made
his fortune through armaments, and used the
proceeds to build himself an impressive house
on a hillside near Rothbury. Using hydroelectric
power from the estate, Cragside was the first
home in the country to have electric lighting.

In 1884 Armstrong was honoured with a visit
by Queen Victoria's son the Prince of Wales,
later King Edward VII (1841–1910), and his wife
Princess Alexandra of Denmark (1844–1925).
This commemorative album in its ornate
binding was commissioned by the inhabitants
of Rothbury and includes an illuminated address
followed by the names of over 230 contributors.

The 25 watercolour plates by local artist
Henry Hetherington Emmerson (1831–95) show
the visitors being welcomed at official receptions
and relaxing on the terrace. They also give a
delightful picture of the house and gardens
and the Armstrong family (including their dogs,
which appear in many of the scenes). NT

Cragside, Northumberland · Royal Visit to Cragside
1884 · *Henry Hetherington Emmerson · Rothbury · 1884 ·
40 x 33cm · 19th-century red and green inlaid morocco
binding with illustrations under glass; bound by Waters of
Newcastle · Presented to Lord and Lady Armstrong by the
inhabitants of Rothbury · NT 3052208 · ‡ 1977*

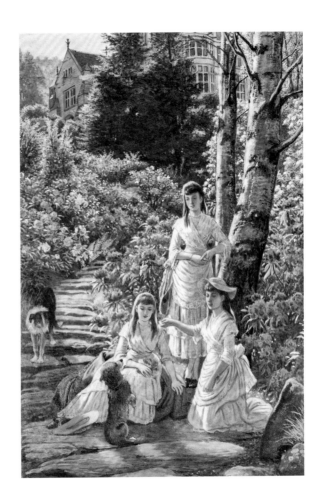

TROUTBECK.—WESTMORELAND.

GEORGE BROWNE, Town End; forked far, under fold bitted near, stroke down tail head, B on near side. Twinters and Lambs, red on head; Lambs, no letter.

MARY B. FORREST, Low House; upper shear bitted near, under shear bitted far, stroke down near shoulder, F on far side. Lambs and Twinters, red on head.

THOMAS CLARK, Junr., Cragg Farm; under key bitted near, upper key bitted far, pop on tail head, T C on near side.

A shepherd's guide

Sheep farming has been a huge influence on the landscape of the Lake District. Lakeland fells are traditionally unfenced and the flocks are hefted, which means they know their land and rarely stray. Sheep were marked with clipped ears and smits (red paint) in a distinctive pattern unique to their farm. To help shepherds identify lost or stolen sheep, local agricultural supplier Daniel Gate (1852–89) produced this guide featuring 1,500 illustrations, taking subscriptions from farmers who wanted their marks recorded. The book also includes an *Essay on Herdwicks*, the ancient native sheep of the fells.

Each page has three standard woodcuts of sheep stamped to show their marks. However, printing this was so complicated that only eight pages could be produced at once. Despite subsidising the publication with advertisements, Gate lost money. The illustrations include marks for sheep owned by George Browne of Townend: these were clipped ears, red rump and the letter B, although lambs and twinters (two-year-old sheep) were marked differently. NT

Townend, Cumbria · Gate's New Shepherd's Guide for Cumberland, Westmoreland, & Lancashire · *Daniel Gate* · *Cockermouth* · *1879* · *25 x 17cm* · *19th-century blue cloth binding* · *NT 3074978*

Evolving tastes

Quarry Bank's cotton mill was owned and run by the Greg family from 1784 and many of their workers lived in the nearby village of Styal. In 1900, Henry Philips Greg (1865–1936) set up a social club there, which was open only to men but included a lending library also used by women and children. The workers' library lent mainly 'serious' fiction and non-fiction for up to a fortnight. By the 1920s, the club's librarian had a budget to buy books, apparently chosen by members with no interference from their employer. This biography of Charles Darwin (1809–82) has the club's ownership stamp and is one of ten books that also contain a subscription library label from the earlier Styal Institution (founded by a local Unitarian minister in 1825), suggesting that books may have been transferred or bought after its closure.

Surviving borrowers' registers for the Styal Village Club provide an interesting illustration of the cultural lives of local residents, the types of book read for entertainment and self-education, and how tastes changed over the lifetime of the library. NT

Quarry Bank Mill, Cheshire · Charles Darwin · *Grant Allen (1848–99) · London · 1888 · 18.8 x 12.8cm · Publisher's blue cloth binding · Styal Village Club Library with blue rubber ownership stamp · Printed label 'Styal Institution Library. No.554' and inscription 'presented by Richard Venables' · NT 3215824*

Theatre royalty

The production of *Macbeth* that was staged at the Lyceum Theatre in London in 1888 has long been considered iconic. Produced by Henry Irving (1838–1905) and starring Ellen Terry (1847–1928) in the role of Lady Macbeth, it was a typically lavish production at what had become the de facto national theatre. Terry's opening night performance and her astonishing beetle-wing dress by the designer Alice Comyns Carr (1850–1927) inspired John Singer Sargent (1856–1925) to paint his famous portrait of the actress.

Terry described *Macbeth* as the most important of her collaborations with Irving and her study copy of the play illustrates this. In addition to being extensively marked up with stage directions, prompts and notes for delivering particular lines, she has pasted in some notes by Irving, together with a loosely inserted lock of his hair. Taken as a whole, it is a testament to her meticulous approach to acting and the captivating nature of her partnership with Irving – one of the greatest in the history of British theatre. TP

Smallhythe Place, Kent · Macbeth, a Tragedy · *William Shakespeare · London · 1888 · 22 x 14.5cm · 19th-century red cloth binding · NT 3119097*

Which shall to all our nights and days to come
Give solely sovereign sway and masterdom.
 Macb. We will speak further.
 —*Lady M.* Only look up clear;
To alter favour ever is to fear.
Leave all the rest to me. [*Exeunt.*

SCENE 6.—*The same.* *Before* MACBETH'S *Castle.*

Enter DUNCAN, MALCOLM, DONALBAIN, BANQUO,
FLEANCE, LENNOX, ROSS, ANGUS, *and* Attendants.

Duncan.

THIS castle hath a pleasant seat; the air
Nimbly and sweetly recommends itself
Unto our gentle senses.
Ban. This guest of summer,

Kelmscotts for Christmas

On 22 December 1938, Sir Sydney Cockerell (1867–1962) sent a Christmas present to his friend Geoffrey Mander (1882–1962), the owner of Wightwick Manor, 'to add to your Morris collection'. The present was a selection of loose, finely printed pages that Cockerell had preserved during his time as secretary to the Kelmscott Press and right-hand man to the designer and artist William Morris (1834–96). The pages – proofs, specimens and trial pages – come from various Kelmscott publications, including Tennyson's *Maud* (1893), Morris's *Earthly Paradise* (1896) and the abandoned *Vitas Patrum* (1894). But it is the pages from *Beowulf* (1895) that are most intriguing, presenting a text that differs from the final published version and providing valuable insights into the editing and printing process of William Morris.

Wightwick Manor is one of the great show-cases for the Arts and Crafts movement, and retains much original Morris & Co. decoration. The library's important collection of Kelmscott Press books – some acquired at the time of publication by Wightwick's founder, Theodore Mander (1853–1900) – is the Trust's largest. TP

Wightwick Manor, West Midlands · Pages from Kelmscott Press · *William Morris* · *London* · *1893–6* · *35.8 x 26.9cm* · *20th-century grey buckram binding* · *NT 3206202*

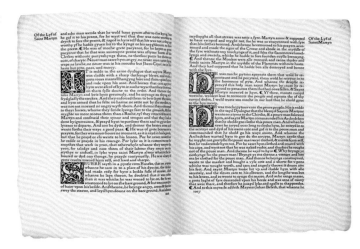

The edges of iron with the poison twigs o'er,stain'd,
With battle,sweat harden'd; in the brunt never fail'd he
Any one of the warriors whose hand wound about him,
Who in grisly wayfarings durst ever to wend him
To the folk,stead of foemen. Not the first of times was it
That battle,work doughty it had to be doing.
Forsooth nought remember'd that son there of Ecglaf,
The crafty in mighty deeds, what ere he quoth
All drunken with wine, when the weapon he lent
To a doughtier sword,wolf: himself nought he durst it
Under war of the waves there his life to adventure
And warrior,ship work. So forwent he the glory,
The fair fame of valour. Nought far'd so the other
Syth he to the war,tide had gear'd him to wend.

XXIII. Beowulf reacheth the mere,bottom in a day's
while, and contends with Grendel's dam ❀ ❀

BUT then spake Beowulf, Ecgtheow's bairn:
Forsooth be thou mindful, O great son of
Healfdene,
O praise of the princes, now way,fain am I,
O gold,friend of men, what we twain
spake aforetime:

Unpublished during his lifetime, the text was entrusted to Wilde's friend and executor Robert Ross (1869–1918), who oversaw its first

Sissinghurst Castle, Kent · De Profundis · *Oscar Wilde* · *London · 1905 · 19 x 12.5cm · Publisher's blue cloth binding · Armorial bookplate: Harold G. Nicolson · NT 3209510*

NIL · SISTERE · CONTRA

Harold G. Nicolson.

DE PROFUNDIS 41

duty towards him begins. It is really ashamed of its own actions, and shuns those whom it has punished, as people shun a creditor whose debt they cannot pay, or one on whom they have inflicted an irreparable, an irredeemable wrong. I can claim on my side that if I realise what I have suffered, society should realise what it has inflicted on me; and that there should be no bitterness or hate on either side.

Of course I know that from one point of view things will be made different for me than for others; must indeed, by the very nature of the case, be made

Ideal but quite impossible.

Vita and Violet

Born around 630BC on the island of Lesbos, little is known of Sappho, except that she came from a wealthy family, was part of the Greek canon of nine lyric poets, and that her poems were highly regarded. Much of the modern debate around her work relates to the theme of romantic love between women.

Canadian poet Bliss Carman (1861–1929) revived Sappho's poems, translating and then imaginatively restoring the fragments into full poems. The copy shown here was owned by the writer Vita Sackville-West (1892–1962). It bears an inscription from the author and socialite Violet Trefusis (1894–1972) dated 1907, an early point in her long and complex relationship with Vita – one that progressed from childhood friendship to intense romantic attachment. YL

Sissinghurst Castle, Kent · Sappho: One Hundred Lyrics · *Bliss Carman · London · 1906 · 16 x 10cm · 20th-century red calf binding · Pictorial bookplate: 'Vita. ... 1908 Knole'* · NT 3188844 · ‡ 2007

SAPPHO
ONE HUNDRED
LYRICS BY BLISS
CARMAN

ALEXANDER MORING LIMITED
THE DE LA MORE PRESS 32
GEORGE STREET LONDON W 1906

Rats!

In 1905 Beatrix Potter (1866–1943) bought Hill Top Farm and almost immediately began incorporating elements of the farmhouse and the village of Near Sawrey into her animal tales. Beginning with *The Pie and the Patty-pan*, published the same year as the farm's purchase, Hill Top would become a character in its own right, and one that remains instantly recognisable to readers of Potter's 'little white books'.

The farmhouse was often visited by rats and they, together with Potter's former pet rat, Sammy, provided inspiration for *The Roly-Poly Pudding* (retitled *The Tale of Samuel Whiskers* in 1926), her mildly horrific tale of cats being terrorised by rats. Her publisher, Frederick Warne & Co., produced this pre-publication mock-up of the book, in readiness for its

publication in an unusually large format. It includes textual revisions and some of the author's early preparatory sketches, including many of the interior of Hill Top and a self-portrait of the author standing in a village setting. TP

Hill Top and Beatrix Potter Gallery, Cumbria ·
The Roly-Poly Pudding · *Near Sawrey?* · 1908 ·
21.6 x 15.9cm · Ink and pencil on paper · NT 242251

1908 — 09

AURORA AUSTRALIS

PUBLISHED AT THE
WINTER QUARTERS
OF THE BRITISH
ANTARCTIC EXPED
ITION, 1907, DURING
THE WINTER MON
THS OF APRIL, MAY,
JUNE, JULY, 1908.
ILLUSTRATED WITH
LITHOGRAPHS AND
ETCHINGS; BY
GEORGE MARSTON

PRINTED AT THE SIGN OF
'THE PENGUINS'; BY JOYCE
AND WILD.
LATITUDE 77° ·· 32' SOUTH
LONGITUDE 166° ·· 12' EAST
ANTARCTICA

TRADE MARK

Southern lights

Acknowledged as one of the greatest Antarctic explorers, Ernest Shackleton (1874–1922) led three successful expeditions to the southern continent. His first was the 1907–9 Nimrod expedition, named after the small sealing ship in which the team sailed from England.

Shackleton had been part of a previous expedition, led by Robert Falcon Scott (1868–1912), which had produced a hand-written newspaper, *The South Polar Times*, and he intended to be the first to print a book in Antarctica. Nimrod expedition members took a three-week printing course run by Messrs Joseph Causten & Sons. The company created a 'penguin stamp' trademark, and supplied a hand-printing press, type, paper and ink.

Making the book, *Aurora Australis*, kept the crew busy during the Antarctic winter of April–July 1908. It included illustrations, poems and articles, among them an account of the first ascent of Mount Erebus. Printing was done in the early morning when vibrations in the cabin were minimal. Candles were essential to keep the ink warm enough to print with.

When finished, the book was hand-sewn with green silk cord. The covers were made from wood taken from the expedition's supply crates, then attached to a leather spine. Copies of *Aurora Australis* were not numbered. There are assumed to be 90–100, of which 25–30 were bound. Dedicated by Shackleton to the Nicolsons, this is referred to as the 'Bottled Fruit' copy because of the product stencilling inside the wooden covers. YL

Sissinghurst Castle, Kent · Aurora Australis · *Ernest Shackleton* · Printed at the Sign of the Penguins · *1908* · 28 x 20.5cm · *20th-century quarter calf binding with Venesta wooden boards* · Inscribed: 'To Sir Arthur and Lady Nicolson from the editor EH Shackleton Jan 1910' · *NT 3212787*

LAMER PARK,
WHEATHAMPSTEAD,
HERTS.

Dear Mr. Kipling

As a member of the main Landing Party of Captain Scott's Expedition I had an edition of your books. I can say quite truthfully that there were no books which we had which were so much used, gave so much food for Conversation & more enjoyment – both to officers and seamen.

And it has occurred to me that you may like to have one of the volumes which we had. & so I am sending you Kim which must have been read & enjoyed by practically all the Shore party.

A well-travelled work

Works by Rudyard Kipling (1865–1936) are an unusual find in a country house library. Wimpole Hall, though, was bought in the 1930s by Kipling's daughter Elsie (1896–1976) and her husband George Bambridge (1892–1943). After Kipling's death, some of the family books were moved from Bateman's to Wimpole. Among them was this seemingly unimportant copy of *Kim*, part of a Macmillan pocket set.

What makes this particular book so interesting is the inscription inside and the letter to Kipling that goes with it. The book spent 1910–13 on the ill-fated Terra Nova expedition to Antarctica led by Robert Falcon Scott (1868–1912). It was a gift to fellow explorer Apsley Cherry-Garrard (1886–1959) from his mother.

At 24, 'Cherry' was the youngest member of the team, his role as assistant zoologist being to study the life cycle of the emperor penguin. During the long Antarctic nights and winters, reading was one of his great comforts. He later returned this copy to Kipling as a souvenir, and his enclosed letter states: '... there were no books which we had which were so much used'. YL

Wimpole Hall, Cambridgeshire · Kim · *Rudyard Kipling* · *London · 1908 · 17 x 11.5cm · Publisher's red leather binding · Inscribed: 'Apsley G.B. Cherry-Garrard June 15th 1910' · NT 3015042*

Mapping the Western Front

During the First World War, as fighting in France and Belgium became a war of attrition along the largely static Western Front, the British Expeditionary Force relied heavily on large-scale maps. Establishing the location of villages, farms, railways, natural features and particularly enemy defences was vital for planning effective attacks and targeting artillery accurately.

Although some maps were based on pre-war mapping, most were produced by the War Office, surveyed by staff from the Ordnance Survey and Royal Engineers. It was important to keep maps up to date and they were regularly reprinted. The trench maps now at Belton House were used at the front by Major Adelbert Cust (1867–1927) while he was acting as Assistant Provost Marshal with the 14th (Light) Division, the IX and XV Corps. He has marked them up with useful information such as Battle Control Posts, Dressing Stations, Prisoners' Cages and Battle Straggler Posts. Cust survived the war and later inherited Belton. NT

Belton House, Lincolnshire · Four Trench Maps ·
*Geographical Section of the General Staff, War Office · England
· 1915–17 · Each map approx. 70 x 90cm · Folded to 17 x 12cm
· Scale 1:20,000–1:100,000 · Ink on paper; mounted on cloth
· Maps used by Adelbert Salusbury Cockayne Cust, later 5th
Baron Brownlow · NT 3191087–90, NT 3191092*

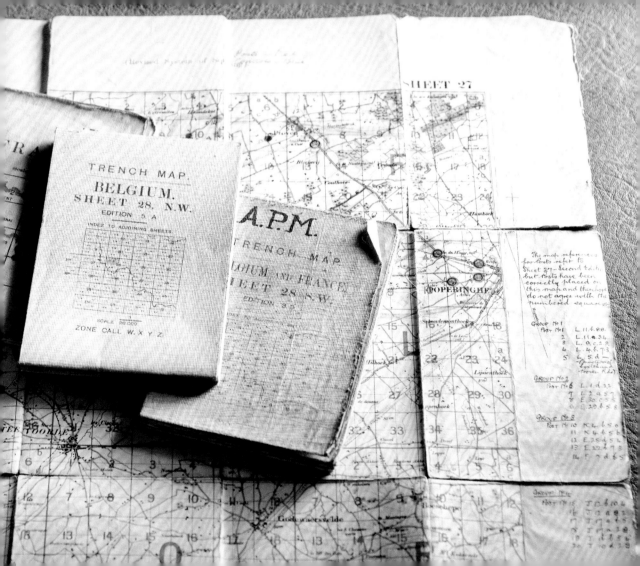

Few books in the Trust's libraries are as poignant, or tell as sad a story, as *Pro Patria* (For Country). Within this slim volume are memorialised Lord and Lady Cawley's three youngest sons, who died fighting in the First World War. Stephen was killed at Néry, France, on 1 September 1914; Harold was shot at close range at Gallipoli on 24 September 1915; and Oswald died at Merville, France, on 22 August 1918.

Pro Patria was probably written and published by the men's father, Frederick Cawley (1850–1937), one of the few Liberal MPs to champion conscription. Photographs and brief biographies of the sons, including frank details of their deaths, are accompanied by laudatory testimonials from friends and colleagues who sent letters of condolence to the family home at Berrington.

As with many contemporary accounts of First World War loss, *Pro Patria*'s grim inevitability and desperate stoicism is matched only by its message of patriotic duty. TP

Berrington Hall, Herefordshire · Pro Patria · *Frederick Cawley · London · 1920 · 18.3 x 13.9cm · 20th-century limp black leather binding · NT 3230563 · Given by Derek Wise in 2018*

Monument in Eye Church.

IN LOVING MEMORY OF
THE THREE SONS OF
LORD AND LADY CAWLEY
OF BERRINGTON HALL
IN THIS PARISH WHO FELL
IN THE GREAT WAR.

*Major John Stephen Cawley,
20th Hussars Brigade — Major
1st Cavalry Brigade. Killed
Sept. 1, 1914, at Néry in France
and is buried there — aged 34.*

*Captain Harold Thomas Cawley,
M.P., 1/6th Manchester Regt. Terr.
Killed Sept. 24, 1915, at Gallipoli
and is buried there — aged 37.*

*Captain Oswald Cawley, M.P.,
Shropshire Yeomanry. Killed
Aug. 22, 1918, near Merville and
is buried at Néry — aged 36.*

PRO
PATRIA

Captain Harold T. Cawley, M.P.

Capt. Harold T. Cawley, M.P.

HAROLD THOMAS CAWLEY, the
second son of Sir Frederick Cawley,
Bart., M.P. (afterwards Lord Cawley
of Prestwich), and Lady Cawley, was born on
June 12, 1878. After a short stay at a preparatory
school he went to Rugby School in 1891, and left
there in 1897 to go to New College, Oxford. At
New College he read for the History (Honours)
School, and took Second Class Honours. Mr.
H. A. L. Fisher, who had to examine him for his
Finals at Oxford, says of his papers :—

. . . . He wrote little, but he put nothing
down on paper which was not perspicuous,
sensible, apposite and correct. He had the
very rare quality, part intellectual and part
moral, of never pretending to knowledge he
did not possess, and of always knowing the
limitations of his knowledge.

One cannot but feel how sorely such a mind was
needed amongst those who had to deal with the
intricate and conflicting elements of the world after
the war.

On leaving Oxford, he studied for the Bar, and
was called at the Inner Temple in 1901. He

*Major John Stephen Cawley
20th Hussars.*

Major John Stephen Cawley

20th Hussars

JOHN STEPHEN CAWLEY (usually known
by his second name), the third son of Sir
Frederick Cawley, Bart., M.P. (afterwards
Lord Cawley), and Lady Cawley, was born in
1879 and was, therefore, nearly thirty-five years
of age at the time of his death in the Great War.
He had a successful school career, first at Lockers
Park, Hemel Hempstead, and later at Rugby. At
both schools he won many of the successes that
schoolboys most ardently desire to achieve. At
Sandhurst, where he went straight from Rugby in
1897, he was a member of both the football Fifteen
and the shooting Eight. He also obtained the more
professional distinctions of prizes for topography
and revolver shooting, and attained the rank of
corporal.

After leaving Sandhurst, he joined the 20th
Hussars, then stationed at Mhow, India, in 1898.
He commenced polo at once and soon became a
member of the regimental team which won the
Inter-Regimental Cup at Meerut in 1901. In the
autumn of that year, his regiment was sent to fight

Captain the Hon. Oswald Cawley, M.P.

Captain The Hon.

Oswald Cawley, M.P.

OSWALD CAWLEY was the fourth and
youngest son of Frederick Lord Cawley of
Prestwich, formerly Sir Frederick Cawley,
Bart., M.P. for Prestwich, and of Lady Cawley, of
Berrington Hall, Leominster. He was educated at
Lockers Park, and at Rugby School, which he
entered in 1896 and left in 1900. He was elected an
Exhibitioner of New College, Oxford, and after
studying on the Continent went up to New College
and took his degree with Second Class Honours in
History. On going down from Oxford, he joined his
father's business, becoming Assistant Manager of the
Heaton Mills Bleaching Company. He spent
most of his leisure time in philanthropic work, being
particularly interested in Lads' Clubs and the Boy
Scouts movement. He was also much interested in
politics, more particularly in his father's division,
for which he later became M.P.

The Rev. J. Lightfoot, the Rector of St. Mary's,
Crumpsall, wrote :—

For years he has been a devoted worker in
connection with the Crumpsall Lads' Club,

one of the super-yachts of its day. At a length of over 250 feet (75 metres), it was the epitome of luxury and included a lavishly appointed library, where this book was read. Several passages are underlined, including one denouncing socialism as 'contrary to human nature'. The identity of the individual who marked these passages is unknown. However, the steam yacht and its

A
HANDBOOK
FOR
ANTI-SOCIALISTS.

BOSWELL PRINTING & PUBLISHING Co. Ltd.
2, Whitehall Street,
London, E.C.4.

SAPPHIRE R.Y.S.

Broughton

Sanctuary in Westminster

For such a heroic figure as T.E. Lawrence (1888–1935), it is perhaps surprising that a major misfortune befell him in the innocuous surroundings of Reading railway station. In the café, during the festive period of 1919, Lawrence left behind the handwritten first draft of his masterpiece, *Seven Pillars of Wisdom*, his account of the Arab Revolt (against the Ottoman Empire) and his role in it. Devastated at the loss of over 200,000 words, but determined to recover the text from memory, he began to write again at a furious pace in the peace and quiet of an attic owned by the prominent architect Herbert Baker (1862–1946) at 14 Barton Street, Westminster. Lawrence described the attic as 'the best-and-freest place I ever lived in'.

Baker was an instant and lifelong friend of Lawrence (it was 'love at first sight' according to the former). His copy of the 1926 subscribers' edition of *Seven Pillars* – which he went through page by page in the company of the author – is inscribed with the address of the book's creation. TP

Owletts, Kent · Seven Pillars of Wisdom · *T.E. Lawrence* · *London · 1926 · 25.8 x 20.2cm · Original dark blue morocco binding with gilt panelling and lettering · NT 3153966*

Birthday greetings

One of the more unusual items in a National Trust collection was presented to the writer George Bernard Shaw (1856–1950) on his 70th birthday in 1926. The compilation 'Birthday Book', a tribute from his many German and Austrian admirers, was organised by the publisher Samuel Fischer (1859–1934) and the playwright Siegfried Trebitsch (1868–1956). Trebitsch had worked with Shaw for decades, translating his plays into German, and they became friends in the process.

The birthday compilation is a boxed set of two volumes. The first contains handwritten greetings from a wide range of authors, musicians and artists; the second is a typescript copy of the messages, made for easier reading. Birthday wishes to Shaw came from such famous names as Albert Einstein (1879–1955, see opposite) and included music as well as words from the composers Arnold Schönberg (1874–1951) and Richard Strauss (1864–1949). In addition, many of the artists invited to sign the book added personalised drawings to their messages. YL

Shaw's Corner, Hertfordshire · Bernard Shaw zum 70. Geburtstage · *Various signatories* · *Berlin?* · *1926* · *30 x 22cm (boxed)* · *20th-century silk binding* · *NT 3201810*

Jederzeit schon fanden sich Menschen, die selbständig genug sind, um die Schwächen und Thorheiten ihrer Zeitgenossen zu sehen und selbst unberührt davon zu bleiben. Aber diese Einsamen verlieren meist bald den Mut, im Sinne einer Gesundung zu wirken, wenn sie die Verstocktheit der Menschen kennen gelernt haben. Nur ganz wenigen ist es gegeben, durch feinen Humor und Grazie die Generation zu fascinieren und ihr auf dem impersönlichen Wege der Kunst den Spiegel vorzuhalten. Den grössten Meister dieser Art grüsse ich heute mit herzlicher Sympathie, der uns alle beglückt und — erzogen hat.

Albert Einstein.

& the trumpets again peal fourth

Truth! Truth! Truth!

The truth was that Orlando was a Woman.

II

The sound of the trumpets died away, & Orlando stood for a moment in all (his) her beauty, to stand naked. Then he/she dressed humbly; &
While this is going forward the ~~no foreigner being~~ since the world
began has ever looked more ravishing; ~~everything~~ ~~with the~~ ~~bit~~ the silver trumpets,
~~actually~~ ~~seemed to~~ ~~submit~~ ~~to~~ ~~the got~~ ~~ed us our hands~~ ~~eyes~~ she said that Even Charity,
~~cry from~~ seemed to cover her body, heaped in, & threw a garment at
Unthinkably out of curiosity, ~~heaped in~~, & threw a garment at
the naked form which ~~I~~ ~~felt~~ ~~that~~ ~~+~~ ~~how ever~~ ~~felt~~ ~~to~~ ~~that by~~ ~~some~~ ~~Week?~~
inches. ~~When~~ Orlando dressed ~~moved~~ in ~~may hardly~~ ~~take~~ ~~Week?~~
~~How~~ ~~position~~ to take advantage ~~of this break~~ ~~came in the narrative~~ ~~to~~
~~the~~ ~~position~~ to take advantage ~~of this break~~ came in the narrative
review our position. X But Orlando in every other
respect remained precisely as he had been.

Orlando had become a woman. Interm way he
memory went back through all the phases of his past life
without encountering any interruption. All that can be said
is that, as an nervous ~~occasion~~, he ~~felt~~ ~~some~~ was rather
reserved about some incidents in his career; & nobody ev
. mention the night of the ~~& great entertainment~~
as to the what happened ~~in~~ the hall
But as he was now undoubt

work this
white
light;

'Orlando was a woman'

No other work of fiction has more resonance with the National Trust's properties or people than *Orlando: A Biography* by Virginia Woolf (1882–1941).

In writing the three-word title at the top of a blank page on the morning of 8 October 1927, she found immediate inspiration: 'No sooner had I done this than my body was flooded with rapture and my brain with ideas.' Woolf found the novel easy to write and enjoyed its creation.

Indeed, the dates in this manuscript of *Orlando* suggest that it was completed in under six months, between October 1927 and March the following year.

The title character of the book – whose life spans the 16th to the 20th centuries, and who changes from male to female partway through the story – was inspired by Woolf's lover Vita Sackville-West (1892–1962), to whom the author presented this specially bound manuscript. With the Sackville family seat, Knole, as a backdrop, Woolf uses the novel to challenge social norms regarding the patriarchy, sexuality and identity, creating a text that continues to be relevant for succeeding generations of readers. TP

Knole, Kent · Orlando: A Biography · *Virginia Woolf · 1928 · 19 x 13cm · 20th-century calf binding · NT 3072441 · Given by Benedict and Nigel Nicolson in 1962*

Londonderry legends

Edith, Lady Londonderry (1878–1959), had a lifelong interest in Celtic legends and folklore. The sumptuous gardens she created at Mount Stewart are full of allusions to mythology and incredible creatures. She named one area of the gardens after the other world in Celtic mythology: Tir nan Òg (Land of the Ever Young).

Tir nan Òg is also a central location in *The Magic Ink-Pot*, the children's book that Lady Londonderry published in 1928. Based on a series of letters that she sent to her youngest daughter, Mairi, and greatly influenced by the work of the Irish mythologist Ella Young (1867–1956), the book uses Mount Stewart as the magical location for supernatural adventures involving the author's children. The stories come alive in the fantastical watercolours by Mount Stewart's resident artist Edmond Brock (1882–1952), who has added an extra illustration at the front of this copy – an ink sketch depicting Lady Edith, her husband Charles and their daughter Margaret atop the Stewart family dragon. TP

Mount Stewart, County Down · The Magic Ink-Pot
· *Edith Helen Vane-Tempest-Stewart, Lady Londonderry* ·
*London · 1928 · 21 x 17.3cm · 20th-century maroon morocco
binding with gilt decoration and lettering · Armorial*

The Magic Ink-pot

THE
MAGIC INK-POT

By

THE MARCHIONESS OF LONDONDERRY

With Illustrations by

EDMOND BROCK AND LADY MARGARET STEWART

MACMILLAN AND CO., LIMITED
ST. MARTIN'S STREET, LONDON
1928

No 3 ↑ & No 5. No 1 ↑ ← Scrubwood's Thorn

Under the thorn on the East Lawn
reading his poems aloud to Pauline
It was blown down about 1915.

NOTES

by Mary Trevelyan, wife of Sir Charles Trevelyan
who inherited Wallington from his father in 1928

*1 No 1 Sir George was very proud of this young lime, but whenever he spoke of
it, I kept silence, because I knew that as soon as we came into Walling-
ton, we should cut it down. as it spoilt the open view across the lawn.

*1 No 2 I was in my bedroom one windy day in 1934 when a crash made me
turn to the window in time to see this birch blown down.

*2 No 7 This is not a Scarlet Chestnut but an Ohio Buck-eye
Charles cut several trees on the east verge of the lawn before
placing the Griffins on the Ha ha. (see next page)

(see next page)

57

1) THE IDEA showing the BEECH with the spreading limb
2) THE SPREADING BEECH. about 1910
3) THE LAST SUMMER 1940
4) THE LAST WINTER 1941

[There used to be 15 Beeches here.
hence the name]

A treasury of trees

For over 100 years, the Trevelyans kept detailed records of tree planting, growth and loss on their Wallington estate. Sir George Otto Trevelyan (1838–1928) first recorded statistics for over 300 trees in a notebook (NT 3008726), taking measurements annually from 1888 to 1924. After his death, these were copied into this second notebook by his daughter-in-law Mary (Molly) Trevelyan (1881–1966), who continued the measuring until the year she died, when her daughter Pauline (1905–88) took over.

The notebook contains facts such as species and planting dates, which are still useful today in identifying trees and understanding the development of the estate. The locations are measured in paces from landmarks, rather like a treasure map. There are also more emotional and subjective views of the family's relationship with their land, including sadness at the loss of beloved trees in storms and accounts of family activities, such as reading in their shade. The book contains many photographs and drawings, some showing the family or their employees. NT

Wallington, Northumberland · Book of Trees · *Mary Trevelyan (née Bell) and Pauline Dower (née Trevelyan) · Wallington · 1928–83 · 25 x 20cm · 20th-century quarter leather and cloth notebook · NT 3008725*

A General's Letters to His Son on *Obtaining His Commission*

Cassell and Company, Ltd
London, New York, Toronto and Melbourne
1917

A war library

During the Second World War, Springhill was requisitioned by the government to house troops, first by the British and then, between 1942 and 1944, by the US Army. Mina Lenox-Conyngham (1866–1961), Springhill's chatelaine, was fascinated by the Americans and, as part of her effort to make them as comfortable as possible, provided them with a library made up of books from her private collection. She inscribed each one with 'Troops Library', wrapped them in brown paper and gave them all unique running numbers. The lending library was made up of at least 52 volumes, 12 of which survive. Most were novels, but one book, *A General's Letters to His Son on Obtaining His Commission*, formerly owned by Lenox-Conyngham's uncle Edward in 1917, is a poignant example of war literature.

The wear and tear of the volumes, and the speculation that some of the missing volumes may have been taken by soldiers, suggests that the library was well used. But not by all troops; the African-American soldiers were segregated and are unlikely to have been granted access. TP

Springhill, County Londonderry · A General's Letters to His Son · *T.D. Pilcher* · London · 1917 · *18 x 11.3cm* · *Publisher's cloth binding* · NT 3242920

11

Beside
the
Bonny
Briar
Bush

an maclaren

26

Ivanhoe

Sir W, Scott

25
The
Vultures
Merriman

89
Broken
Earthenware

H. Begbie

32
The King's
Widow

4
The
House
of
Defence

E.F.
Benson

50
a
General's
Letters
to
his
son

34
High
Roads
of
History

40
One
good
Turn

Just John

The well-used state of this copy of *William the Gangster* shows just how much it was enjoyed and cherished by its former owner, the Beatle John Lennon (1940–80). Like millions of other young readers, he devoured the stories of William Brown, the rebellious 11-year-old created by fellow Lancastrian Richmal Crompton (1890–1969). Lennon was introduced to the 'Just William' stories by his Aunt Mimi, with whom he lived at Mendips, but he soon started collecting the books himself, no doubt identifying with the various epithets used by Crompton to distinguish the books – the Outlaw, the Rebel, the Showman – and the mischievous behaviour of the title character.

William was one of Lennon's earliest heroes, a role model of such importance that no biography of the musician and activist is complete without making reference to the stories. His lifelong fondness for them is also demonstrated by Crompton being one of the people originally proposed for inclusion on the album cover of *Sgt. Pepper's Lonely Hearts Club Band* (although she did not make it into the final image). TP

Mendips, Merseyside • William the Gangster • *Richmal Crompton* • London • 1949 • 19 x 13cm • *Publisher's printed paper dust-jacket, red cloth binding* • NT 3037875 • *Given by Yoko Ono in 2009*

From films to food poisoning

Preserved behind an 18th-century shopfront in the Northern Ireland town of Strabane, Gray's Printing Press (see page 12) is a remarkable survival. It dates back to a time when Strabane was a key centre of Irish printing, and the building houses a fine selection of historical hand presses, type specimens and a significant tranche of the press's 20th-century printed output.

Taken as a whole, the printed items that survive – many of which are now as rare as medieval manuscripts – represent an invaluable social document of life in a small Irish town and the central role played by the local printer. Numerous colourful posters with idiosyncratic typefaces survive, many of them advertising events that might not otherwise be mentioned in the historical record – the opening of an underwear shop, for example, or an evening of all-star wrestling matches. The poster here advertises a film screening of a recent visit by Lord Wakehurst (1895–1970), the Governor of Northern Ireland, somewhat awkwardly paired with a talk on the perils of food poisoning. TP

Gray's Printing Press, County Tyrone · A Colour Film of the Recent Parade & Inspection · *Strabane · 1954 · 54.7 x 38.3cm · Ink on paper · NT 3033339*

Above · Advertising poster for the public performances of the Ormesby Hall production of *Henry V*, July 1959 (NT 3243423).

A theatrical hotspot

The staging of Shakespeare's *Henry V* across six nights in July 1959 was just one in a series of plays performed at Ormesby Hall from the 1920s onwards. Theatre was a passion of Ruth Pennyman (1893–1983), who wrote plays from a young age and who, with her husband Jim (1883–1961), established Ormesby as a key location in post-war British theatre. Many theatre companies found a home there, including the Theatre Workshop established by Joan Littlewood (1914–2002), which stayed for 18 months in 1946–7. In Littlewood, Pennyman found a kindred spirit who understood the power of theatre for social good, a sentiment confirmed through Pennyman's involvement with the Everyman Theatre at the influential Spennymoor Settlement in County Durham.

This extensively marked-up and annotated copy of *Henry V* (opposite), with Pennyman's pencil still attached, was used by her in directing the play. Like many of the Ormesby productions, it was an epic affair, involving nearly 80 people drawn largely from the local community and staged in the floodlit stable courtyard. TP

Ormesby Hall, North Yorkshire · King Henry V · *William Shakespeare* · London · 1909? · 16.8 x 11.5cm · *Publisher's printed paper wrappers* · *Part of Ruth Pennyman's New Theatre Group borrowing library at Ormesby Hall* · *NT 3224834*

Ere he take ship for France, and in Southampton
Linger your patience on; and we 'll digest
The abuse of distance; force a play: 30
The sum is paid; the traitors are agreed;
The king is set from London; and the scene
Is now transported, gentles, to Southampton;
There is the playhouse now, there must you sit;
And thence to France shall we convey you safe,
And bring you back, charming the narrow seas
To give you gentle pass; for, if we may,
We 'll not offend one stomach with our play.
But, till the king come forth, and not till then, 40
Unto Southampton do we shift our scene. [*Exit.*

SCENE I. *London. A street*

Enter Corporal NYM *and Lieutenant* BARDOLPH.

Bard. Well met, Corporal Nym.

Nym. Good morrow, Lieutenant Bardolph.

Bard. What, are Ancient Pistol and you friends yet?

Nym. For my part, I care not: I say little; but when time
shall serve, there shall be smiles; but that shall be as it may.
I dare not fight; but I will wink and hold out mine iron: it
is a simple one; but what though? it will toast cheese, and
it will endure cold as another man's sword will: and there 's
an end.

Bard. I will bestow a breakfast to make you friends; and
we 'll be all three sworn brothers to France: let it be so, good
Corporal Nym. 11

Nym. Faith, I will live so long as I may, that 's the certain
of it; and when I cannot live any longer, I will do as I may:
that is my rest, that is the rendezvous of it.

Bard. It is certain, corporal, that he is married to Nell
Quickly: and certainly she did you wrong, for you were troth-
plight to her.

Nym. I cannot tell: things must be as they may: men may
sleep, and they may have their throats about them at that
time; and some say knives have edges. It must be as it may:
though patience be a tired mare, yet she will plod. There
must be conclusions. Well, I cannot tell. 23

Enter PISTOL *and* Hostess.

Bard. Here comes Ancient Pistol and his wife: good cor-
poral, be patient here. How now, mine host Pistol!

Pist. Base tike, call'st thou me host?
Now, by this hand, I swear, I scorn the term;
Nor shall my Nell keep lodgers. [*Nym and Pistol draw.*

Host. O well a day, Lady, if he be not drawn now! we shall
see wilful murder committed. 30

Bard. Good lieutenant! good corporal! offer nothing here.

Nym. Pish!

Pist. Pish for thee, Iceland dog! thou prick-ear'd cur of
Iceland!

Host. Good Corporal Nym, show thy valour, and put up
your sword.

Nym. Will you shog off? I would have you solus.

Pist. "Solus", egregious dog? O viper vile!
The "solus" in thy most mervailous face;
The "solus" in thy teeth, and in thy throat, 40
And in thy hateful lungs, yea, in thy maw, perdy,
And, which is worse, within thy nasty mouth!
I do retort the "solus" in thy bowels;
For I can take, and Pistol's cock is up,
And flashing fire will follow.

Nym. I am not Barbason; you cannot conjure me. I have
an humour to knock you indifferently well. If you grow foul
with me, Pistol, I will scour you with my rapier, as I may, in
fair terms: if you would walk off, I would prick your guts a
little, in good terms, as I may: and that 's the humour of it.

Pist. O braggart vile and damned furious wight! 51

Star-studded Shakespeare

On 11 May 1952 Benthall Hall welcomed two major stars of stage and screen: Katharine Hepburn (1907–2003) and Robert Helpmann (1909–86). Both were in England to star in a West End production of *The Millionairess* by George Bernard Shaw (1856–1950), and had been taken to the Benthall ancestral home by Michael Benthall (1919–74), the director of the all-star play (and Helpmann's partner), for a break in the rehearsing schedule.

The play was a great success and a year later Benthall took on the role of artistic director of the Old Vic theatre. His nine-year tenure there was dominated by an ambitious staging of all the plays in the Shakespeare First Folio. The cast lists include some of the great names of British theatre: John Gielgud (1904–2000), Richard Burton (1925–84) and Judi Dench (b.1934).

In recognition of his directorship, in 1963 the Old Vic presented Benthall with this signed three-volume set of Shakespeare's plays, sumptuously illustrated with production photographs by Angus McBean (1904–90), and original stage and costume designs by luminaries such as Cecil Beaton (1904–80). TP

Benthall Hall, Shropshire · The Plays of William Shakespeare · *London · 1874–8 · 32 x 26cm · 20th-century half blue morocco and cloth binding · NT 3046445*

Opposite · Autographed page including the signatures of Vivien Leigh, Robert Helpmann and Bruce Montague.

Left · Some of the bound-in photographs and designs, clockwise from top left: costume design by Kenneth Rowell for the 1953 production of *Hamlet*, directed by Michael Benthall; John Neville as Hamlet and Judi Dench (making her professional debut) as Ophelia in the Old Vic production of 1957; title design by Loudon Sainthill for the 1958 production of *Henry VIII* starring Sir John Gielgud and Dame Edith Evans; Robert Helpmann as Richard III in the Old Vic production of 1957.

Brothers in the struggle

Andrew Salkey (1928–95) was a key figure among the writers and intellectuals who migrated to Britain in the years following the Second World War. From the mid-1950s, Salkey became a lynchpin of the Black literary community, fronting the BBC World Service's Caribbean content and forming the influential Caribbean Artists Movement in 1966. In 1973 his poem *Jamaica* was published – a powerful and direct epic that confronts the island's colonial history.

One of Salkey's contemporaries in London was the Kenyan writer Khadambi Asalache (1935–2006), whose 1967 novel *A Calabash of Life* is a pioneering example of post-colonial literature, and whose collected poetry was also published in 1973. It is not known how Asalache and Salkey met – possibly at Turret Bookshop, an important literary meeting place in Kensington – but they were obviously aware of each other's literary careers, and their pivotal roles as Black writers in England. This is demonstrated by the powerful inscription in Asalache's copy of *Jamaica*: 'For Khadambi, my brother and fellow poet, in the struggle'. TP

575 Wandsworth Road, London · Jamaica · *Andrew Salkey* · London · 1973 · 21.5 x 12.5cm · Publisher's printed paper covers · NT 3180840

The World of Jeeves

To
Agatha Christie
from P. G. Wodehouse

with homage and
admiration and hoping
that one g these days
I may succeed in
spotting who dun it
before the final chapter

Oct 25-1968

Who dun it

Agatha Christie (1890–1976) was one of the few authors that P.G. Wodehouse (1881–1975) thought worth reading, so at the beginning of 1955 he determined to let her know: 'With infinite sweat I wrote her a long gushing letter, and what comes back? About three lines, the sort of thing you write to an unknown fan.' This inauspicious start developed into a flourishing pen-pal relationship between two of the 20th century's greatest authors, which lasted until Wodehouse's death.

This collected edition of Jeeves short stories, with a charming inscription by Wodehouse, was presented to Christie in 1968. She kept it in the library of her holiday home, Greenway, and treasured it so much that her next Poirot novel (*Hallowe'en Party*, published in 1969) was dedicated: 'To P.G. Wodehouse – whose books and stories have brightened my life for many years. Also, to show my pleasure in his having been kind enough to tell me he enjoyed my books.' TP

Greenway, Devon · The World of Jeeves · *P.G. Wodehouse · London · 1967 · 23 x 16cm · Publisher's dust-jacket and blue cloth binding · Inscribed by P.G. Wodehouse: 'With homage and admiration and hoping that one of these days I may succeed in spotting who dun it before the final chapter' · NT 3176260*

Land of my fathers

In 1974 the great Welsh artist Kyffin Williams (1918–2006) returned to Ynys Môn (the Welsh name for Anglesey), the island of his birth, after decades away in London. His search for suitable studio space led him to a former inn in the village of Pwllfanogl, rented to him by his close friends, Henry and Shirley Paget, Lord and Lady Anglesey (1922–2013 and 1924–2017 respectively), owners of Plas Newydd. He described his time as a tenant of the Pagets as 'one of the most satisfactory periods of my life'.

Lady Shirley, the dedicatee of Williams's 1991 autobiography, was an enthusiastic purchaser of this volume of his linocuts, which was published by Gwasg Gregynog, the successor of the most important Welsh private imprint, the Gregynog Press. Williams, fully aware of the press's proud heritage, designed the book and took an active interest in the production process. A triumph of fine printing, it includes a number of images of Anglesey (below left) in which Williams has captured the island's 'air of mystery as well as of continuity'. TP

Plas Newydd, Anglesey · Cutting Images · *Kyffin Williams* · *Newtown* · *2002* · *25 x 30cm* · *Quarter leather with buckram boards by John Sewell* · *NT 3235902*

Glossary of terms

Armorial · A coat of arms, crest or other heraldic device, often added to books to denote ownership.

Boards · The sides of a bound book, made from materials including wood, pasteboard and paper. Sometimes used to mean the original binding of paper over boards, as issued by publishers in the late 18th and early 19th centuries.

Book label and bookplate · A piece of paper, often with an illustration, fixed inside a book to indicate ownership. Book labels tend to be smaller than bookplates, with simpler ownership marks, often just the owner's name.

Calf · Leather made from the hide of a calf.

Dissected and mounted (maps) · Cut into sections and pasted onto a backing to make them more durable and easier to fold.

Duodecimo *See* Format

Edition, state, issue · When the type is set for a book, all the copies printed from that setting are the edition. If small changes are made to the type while the edition is being printed, those variants are called states. Sometimes the same setting was used with different title pages for separate booksellers, or reused at a later date: these variants are different issues.

Endpapers · The blank or decorated leaves inserted as protection at the beginning and end of a book when it is bound. The endpapers pasted to the inside of a book's cover are known as paste-downs. The other leaves are called free endpapers, sometimes known as flyleaves.

Folio *See* Format

Format · The size of a book in the hand-press period (before *c.*1820), sometimes described in terms of the way in which a sheet of paper is folded. For a folio, the sheet is folded once, making 2 leaves (4 pages), producing a large, rectangular book. Two folds make a quarto of 4 leaves (8 pages), and a squarer book. An octavo has three folds, 8 leaves (16 pages) and is a smaller rectangular book. A duodecimo or 12mo always has 12 leaves, but can be produced by folding in several different ways. Further folding gives even smaller-format books, such as sextodecimo (16mo), 24mo and 32mo.

Half bound · A style of binding where the spine and front corners are covered in one material, e.g. leather, while the rest of the book is covered with paper or cloth. *See also* Quarter bound

Illuminated · Manuscripts and early printed books that are decorated by hand in gold, silver and/or coloured paints.

Inlaid · Describes a leather cover in which a decorative shape has been cut out and replaced with the same shape in a different coloured leather to form a decorative pattern.

Issue *See* Edition

Leaf *See* Format

Lithography · A process of printing invented in 1798 that uses the repulsion between ink and water to print from a flat surface.

Manuscript · A work written by hand.

Marbling · A decorative effect added to paper by laying it in a trough containing gum (or a similar substance) mixed with water to increase its surface tension, then placing ink on top and manipulating it to produce a pattern of swirls.

Morocco · Tanned goatskin used for bindings, often coloured.

Octavo *See* Format

Panelling · A binding with rectangular decoration, which can be blind (plain) or gilt.

Parchment *See* Vellum

Paste-down · The endpaper that has been pasted to the inside of a book's cover.

Provenance · Information about the previous ownership of a book.

Quarter bound · A style of binding where the spine is covered in one material, while the boards (including the corners) are covered in another. *See also* Half bound

Quarto *See* Format

Sextodecimo *See* Format

Sheep · Soft leather made from sheepskin. It could be split into two layers and used for cheaper bindings.

Stab-stitched · A form of stitching used for slim publications, such as pamphlets and magazines. Instead of sewing along the fold of the sheets, the needle is 'stabbed' through sideways.

State *See* Edition

Ties · Fastenings of ribbons, leather or vellum strips attached to the front of each board, which could be tied together to keep a book closed.

Tooling · Decoration on bindings created by engraved metal tools being hand-pressed into the leather; often blind (with no colour) or gilt (gold leaf).

Uncial script · A high-grade book script with rounded letterforms used in early manuscripts.

Uncut · Leaves that have not been trimmed by a binder and retain their original rough edges.

Unopened · A book in which the leaves are still connected by the original folds in the sheet. For the book to be read, the folds have to be slit with a paper knife or cut off by a binder.

Vellum · A material originally made from calfskin, though sheepskin and goatskin could be used. The skin was dried and scraped until translucent to produce parchment, which was used as a writing surface and for bindings.

Vignette · A small ornament or illustration used as a break in a text.

Woodcut · A type of illustration produced by cutting into wood with a knife.

Wrappers · Paper, vellum or cloth covers, usually intended as a temporary binding.

Gazetteer of National Trust Places

For full details of every National Trust property, including further information about collections, opening times, events and facilities, please visit the National Trust website (www.nationaltrust.org.uk) and the National Trust Collections website (www.nationaltrustcollections.org.uk). Library collections can also be searched online at Library Hub Discover (discover.libraryhub.jisc.ac.uk).

A La Ronde, Devon · Curious 16-sided cottage built for the Misses Parminter in 1798 on their return from a European tour. Packed with an eclectic collection of books, shells, bead-work, feathers and cut paperwork.

Anglesey Abbey, Cambridgeshire · 13th-century priory converted into a comfortable manor house. Its library of mostly 20th-century books was assembled by the Anglo-American oil magnate Huttleston Broughton, 1st Lord Fairhaven, and is principally of note for its collections of 19th- and 20th-century fine bindings and colour-plate books, many in near mint condition.

Arlington Court and the National Trust Carriage Museum, Devon · Neo-classical house built for Colonel John Chichester by Thomas Lee. An eclectic collection largely assembled by avid collector Miss Rosalie Chichester. Contains a few books, including the *Arlington Psalter*.

Bateman's, East Sussex · The former home of British author Rudyard Kipling, with a comprehensive collection of his family's personal belongings, including much of his working library.

Belton House, Lincolnshire · Late 17th-century mansion with one of the Trust's largest libraries, assembled by successive generations of the Brownlow family over four centuries. Despite some historic sales, the collection still has rich holdings of manuscripts, books printed before 1801, grand tour literature, music, and a significant collection of unbound pamphlet material.

Benthall Hall, Shropshire · 16th-century house with early 17th-century interiors, associated for centuries with the Benthall family. A small number of books are owned by the National Trust.

Berrington Hall, Herefordshire · Neo-classical mansion built for Thomas Harley, son of the 3rd Earl of Oxford, and purchased in 1901 by Liberal MP Frederick Cawley. Its impressive pedimented bookcases now contain mainly 19th- and 20th-century books from the Cawley family collection, covering many subjects, including English literature, history, topography, gardening and travel.

Blickling Hall, Norfolk · Jacobean house built for Sir Henry Hobart. The library, now housed in the Jacobean Long Gallery, includes the remaining Hobart family books, plus a large bequest of other volumes from a distant cousin, Sir Richard Ellys. The Hobarts continued to collect, and later owners include the first three Earls of Buckinghamshire and their wives, Caroline, Lady Suffield and the 9th–11th Marquesses of Lothian.

Calke Abbey, Derbyshire · Baroque mansion in which the family library, assembled by the Harpurs and Crewes over three centuries, is full of useful books, many in original bindings. The library of Sir John Gardner Wilkinson, bequeathed to the 9th Baronet, covers a wide range of subjects, including Egypt, eastern Europe, art and politics. Its many pamphlet volumes and presentation copies include correspondence with notable figures. Wilkinson's archive is now on deposit at the University of Oxford.

Carlyle's House, London · The Chelsea home of the Victorian writer and historian Thomas Carlyle and his wife Jane Baillie Welsh, which contains part of Carlyle's working library. Other books were given by Carlyle to Harvard, to friends and associates, or sold at auction in 1932.

Castle Ward, County Down · An 18th-century house of contrasts, featuring both Palladian and Gothic Revival architecture. The library holds Ward family books from the 17th to 19th centuries, including those owned by Michael Ward of Bangor and the Hamiltons of Killyleagh Castle. It has a strong collection of Irish books and early Continental printing.

Cherryburn, Northumberland · A farm in the Tyne Valley, birthplace of wood engraver Thomas Bewick. Contains a small library of material built around the collection of Justin Schiller (acquired by the Thomas Bewick Birthplace Trust and passed to the National Trust in 1991), which includes manuscripts and publications, including proofs, illustrated by or connected to Bewick.

Coughton Court, Warwickshire · Tudor and Gothic Revival house, home to the prominent Roman Catholic family of Throckmorton since 1409. It holds a collection of Catholic treasures, including a small group of medieval manuscripts, and a 17th-century travelling library.

Cragside, Northumberland · Victorian house built for the manufacturer William Armstrong. The family book collection is mostly from the later 19th and 20th centuries, but contains a small number of earlier books owned by Armstrong's mentor Armorer Donkin, a Newcastle solicitor. A small collection of books is marked as being from the servants' quarters.

Dorneywood, Buckinghamshire · 18th-century brick house with an impressive collection of working books and fine bindings (mostly English, 1660–1800) assembled by the donor, Lord Courtauld-Thomson. It also includes a

significant collection of books owned by his brother-in-law, Kenneth Grahame. In accordance with the donor's wishes, the house is used as the official residence of a government minister.

Dunham Massey, Cheshire · Georgian house built 1720–38 for the 2nd Earl of Warrington. The 18th-century closet-style library is an unusual survival, housing books assembled primarily by the 1st and 2nd Earls and Mary Grey, Countess of Stamford. This is a good example of an early private library full of 'ordinary' books, many with evidence of use.

Dyrham Park, Gloucestershire · Baroque mansion nestled in an ancient deer park, built by William Blathwayt, Secretary at War to William of Orange. The interiors and collections have a strong Dutch influence. The book collection includes remnants of Blathwayt's library.

Erddig, Wrexham · Country house with Neo-classical interiors. The large library assembled by the Yorkes reflects the reading and practical concerns of the family over 200 years, and is of interest as an intact historic Welsh collection that closely reflects the history of the house.

Felbrigg Hall, Norfolk · One of the finest 17th-century houses in Norfolk, built around the carcass of a Tudor building. The large library of the Windham family includes books collected since the 17th century, the most recent addition being the working collection of the last squire, the antiquarian Robert Wyndham Ketton-Cremer.

Gray's Printing Press, County Tyrone · A treasure trove of ink, wooden and metal type and printing machinery hidden behind an 18th-century shopfront in the heart of Strabane, once a prominent printing town in Ulster and birthplace of the man who printed the American Declaration of Independence. The collection contains much ephemeral printing, including posters and advertisements.

Great Chalfield Manor, Wiltshire · Medieval manor house near Melksham, built around 1465 by Thomas Tropenell. Its star item is the *Tropenell Cartulary*, but the collection also contains a volume of drawings of Great Chalfield by Thomas Larkins Walker, a pupil of the architect Augustus Pugin, used in the 20th-century restoration by Major Robert Fuller.

Greenway, Devon · Georgian house that was the holiday home of Agatha Christie and her family. Most of the books now in the house belonged to her daughter and son-in-law, but there is a large collection of first editions and association copies.

Gunby Hall, Lincolnshire · The home of the Massingberds for more than 250 years, built *c.*1700. The small family library, containing books from the 16th to 19th centuries, is rich in evidence of ownership. The Study contains more recent books from the working library of Field Marshal Sir Archibald Montgomery-Massingberd.

Hardwick Hall, Derbyshire · Impressive 16th-century house built for Elizabeth Talbot, Countess of Shrewsbury, commonly known as Bess of Hardwick. The early library moved to Chatsworth House, main residence of the dukes of Devonshire. The present-day collection includes an interesting variety of books with family provenance from the 16th to 20th centuries, some transferred as duplicates from Chatsworth, including books owned by the scientist Henry Cavendish.

Hill Top and Beatrix Potter Gallery, Cumbria · Small 17th-century farmhouse bought by Beatrix Potter and featured in her illustrations. The Potter family books were mostly bequeathed to the Armitt Library, but some remain at Hill Top, along with a collection of earlier books from the family of Potter's husband, William Heelis. The Gallery, formerly Heelis's office, displays publications and manuscripts by Potter.

Hughenden, Buckinghamshire · Country home of Victorian prime minister Benjamin Disraeli. His working library (slightly depleted by a 20th-century sale) reflects his political interests and includes presentation copies from notable figures. The library also includes a substantial remnant of the collection amassed by his father, the author Isaac D'Israeli.

Kedleston Hall, Derbyshire · 18th-century Neo-classical house largely designed by Robert Adam. The historic Curzon family collection, still shelved in the original cases of the Adam Library, is rich in European printing and contains stunning architectural books. The collection also contains the working library of George Nathaniel Curzon, who was Viceroy of India.

Killerton House, Devon · Georgian house set in 6,400 acres of parkland. It is home to a large collection of printed music of the late 18th and early 19th centuries that comes from the original library of the Acland family.

Kingston Lacy, Dorset · Grand 17th-century house, home to the Bankes family for more than 300 years. It contains the impressive library of the Bankes family, including many pre-1801 books (many printed on the Continent), along with annotated and inscribed books. Its many important early bindings include a Jean de Planche binding for Sir Nicholas Bacon.

Knole, Kent · Tudor archbishop's palace and home of the Sackville family for 400 years. Most of the historic family library is owned by the Sackville Trust, but a handful of books has been acquired by the National Trust over the years, including the manuscript of Virginia Woolf's *Orlando* (1928).

Lacock Abbey and Fox Talbot Museum, Wiltshire · Unusual 16th-century country house with later Gothic-style alterations built on the foundations of a former nunnery and later owned by photography pioneer William Henry Fox Talbot. A large library, rich in 17th- and

18th-century books, some clearly in the Abbey since the 17th century, supplemented by Talbot's collection.

Lanhydrock, Cornwall · Originally a Jacobean house built for Richard Robartes, refurbished in 1881 after a devastating fire to produce a late-Victorian country house for the Agar-Robartes family. Lanhydrock is the National Trust's largest early library.

Lytes Cary Manor, Somerset · Small medieval manor house with associated chapel and gardens, it has parts dating back to the 14th century. Lovingly restored by Walter Jenner in a 17th-century style. It has a few remaining books, including Henry Lyte's English translation of Rembert Dodoens' herbal.

Mendips, Merseyside · The childhood home of John Lennon, who lived there with his aunt Mimi Smith. A small collection of Lennon's books was donated to the property by his widow Yoko Ono in 2009.

Moseley Old Hall, Staffordshire · An atmospheric Elizabethan farmhouse, notable for its association with Charles II, who sheltered there after the Battle of Worcester in 1651. The small book collection, mainly from the Civil War period, has been added to by later owners.

Mount Stewart, County Down · Neo-classical house, home to the Marquesses of Londonderry. The library has good holdings of history and politics from the 18th to the 20th centuries, particularly relating to Lord Castlereagh. It also has a good range of Irish, Scottish and English literature collected by Edith, Lady Londonderry, with much on the Celtic heritage of Ireland and from the Irish literary renaissance.

Mr Straw's House, Nottinghamshire · Edwardian semi-detached house in Worksop bought in 1923 by grocer William Straw and kept essentially unchanged by his sons after their mother Florence's death in 1939. The collection includes 19th- and 20th-century family books. Over more than 60 years, William Straw Jr assembled a strong collection on local and national history, language, literature and education. He also kept many booksellers' catalogues and invoices, making this an interesting resource for historians of 20th-century book collecting.

Nostell, West Yorkshire · A Palladian house built on the site of a medieval monastery. Parts of the Nostell library have been in the Winn family since before the house was built, but it was greatly expanded in the 19th century by Charles Winn, an enthusiastic antiquarian and collector.

Nunnington Hall, North Yorkshire · The many historical owners and tenants of this Ryedale manor house include the Graham family from the mid-17th century. Manuscripts and books relating to Richard Graham, 1st Viscount Preston and his family were donated with a collection of Jacobite memorabilia by Graham's descendants Alexander and Richard Hamilton.

Ormesby Hall, North Yorkshire · Classic Georgian mansion, home to the Pennyman family for nearly 400 years. The book collection is mostly from the later 19th and 20th centuries, and is strong in theatrical and left-wing literature, reflecting the interests of its owners, Jim and Ruth Pennyman.

Owletts, Kent · Charles II house containing the library of its last owner, the renowned architect Sir Herbert Baker. The collection is strong in association copies, reflecting Baker's friendships with key figures in British and colonial history, including T.E. Lawrence and Cecil Rhodes.

Oxburgh Hall, Norfolk · Moated brick manor house built in 1482 and altered over the centuries. Home to the Catholic Bedingfeld family for 500 years, it retains items relating to their faith and interests, including the remains of a modest family library.

Petworth, West Sussex · Set within a 'Capability' Brown landscape and inspired by the Baroque palaces of Europe, Petworth has many fine collections. From its libraries, the National Trust now owns the Petworth Chaucer manuscript (*c.*1430) and a collection of Jacobean play quartos.

Plas Newydd, Anglesey · A family home remodelled in the 19th century and again in the 1930s. The books were collected mostly by the 7th Marquess of Anglesey, but include a small number of items from the Paget family collection from the house of Beaudesert, Staffordshire.

Polesden Lacey, Surrey · Regency villa with opulent Edwardian interiors. The library of the socialite and collector Margaret Greville includes books inherited from her father William McEwan (the brewing magnate) and a well-selected collection of association copies and art books.

Powis Castle, Powys · Medieval castle, remodelled by generations of the Herbert family, with a collection of Indian objects owned by Edward Clive, son of 'Clive of India', who married Henrietta Herbert in 1784. The National Trust owns only a small number of books here, including *The Powis Hours* and a Persian manuscript of the 14th-century poet Ḥāfiẓ in a lacquered binding.

Quarry Bank, Cheshire · One of Britain's greatest industrial heritage sites, showing how a complete working community lived. The diverse collection includes the books and business archive of the Greg family, who ran the mill and lived at Quarry Bank House. It also includes the Styal Village Club Library that they set up in 1900 for local workers.

Saltram, Devon · A Georgian mansion with a saloon and library designed by Robert Adam. The library of the Earls of Morley consists mostly of working books of the period 1730–1830. It also contains many local and ephemeral books and pamphlets, and a number of remarkable treasures.

Shaw's Corner, Hertfordshire · Edwardian rectory that was the home of George Bernard Shaw and his wife Charlotte Payne-Townshend

from 1906 to 1950. Shaw's life as an author, critic, wit and political activist is reflected in a diverse collection that includes representations of him on everything from bookends to puppets and a doorknocker. The book collection is his working library, almost all printed in his lifetime.

Sissinghurst, Kent · Elizabethan mansion and celebrated gardens purchased and restored by writers Vita Sackville-West and Harold Nicolson. Their working libraries contain mostly 20th-century first editions, annotated books, review copies (often with the reviews inserted) and presentation copies.

Sizergh, Cumbria · Medieval house, home to the Strickland family for more than 800 years. The core of the library today is a collection of local and family history assembled by Henry Hornyold in the 20th century, although some earlier family books remain.

Smallhythe Place, Kent · A 16th-century farmhouse that was home to the Shakespearean actress Ellen Terry. The library reflects Terry's life and career, and is rich in rare and ephemeral publications, including limited editions produced for use in theatrical productions. The collection also includes books associated with Terry's children, Edward Gordon Craig and Edie Craig.

Snowshill Manor, Gloucestershire · A 16th- and 17th-century country house restored by the architect Charles Paget Wade. The books and manuscripts were often purchased for their physical properties rather than their texts, and usually placed in his carefully choreographed themed rooms. The books date from the 15th to 19th centuries and include some from Wade's childhood nursery.

Speke Hall, Merseyside · Tudor timber-framed manor house on the edge of Liverpool, owned first by the Norris family and later by the Watts, merchants who made their fortune in the transatlantic slave trade. It contains a small collection of Watt family books, mainly 18th and 19th century.

Springhill, County Londonderry · Manor house built for the Conynghams in the late 17th century. It contains one of the most remarkable historic libraries in Ireland. The family collection includes books from their cousins the Lenoxes, merchants in Londonderry, and others that had once been at Lissan House, County Tyrone, and Blessington House in County Wicklow.

Tatton Park, Cheshire · Neo-classical mansion, home to generations of the Egerton family. Despite historic sales, the Egertons' library is substantially intact, with rich and varied collections including Italian Renaissance books, first editions of Jane Austen, printed and manuscript music, and Victorian books on ethnography. Tatton is managed by Cheshire East Council on behalf of the National Trust.

Townend, Cumbria · 17th-century yeoman farmhouse, home to the Brownes – farmers,

lawyers and doctors – for over 400 years. It contains the family's remarkable and unique collection. Rich in human interest and with numerous annotated books, the library also includes many rare early books and chapbooks.

Ty'n-y-Coed Uchaf, Conwy · 19th-century farmhouse and smallholding on the Ysbyty estate, with a small collection of mostly Welsh books assembled by several generations of Welsh hill farmers from the 1800s to 1981.

Tyntesfield, North Somerset · Victorian Gothic Revival house containing a large library of mostly 19th-century books, assembled by the Anglo-Catholic Gibbs family. Carefully arranged by subject on the shelves of the great room designed to house them, they are perhaps the Trust's finest and most undisturbed collection of High Victorian books.

Upton House, Warwickshire · Late 17th-century house remodelled in 1927–9 for Walter Samuel, the 2nd Viscount Bearsted, whose family founded the Shell Oil company. The remnants of the Bearsted library include several fragments of medieval manuscripts.

Waddesdon Manor, Buckinghamshire · French Renaissance-style chateau built in the 1870s for Baron Ferdinand de Rothschild. Now managed by the Rothschild Foundation on behalf of the National Trust, it has a wonderful collection of French books, many in bindings of the highest quality, often of royal or aristocratic provenance.

Wallington, Northumberland · A William and Mary house remodelled in the 18th century. The library dates mainly from the late 19th and 20th centuries and is the working collection of the Trevelyans, a family of radical liberal landowners. The collection includes a substantial part of the library of the historian Lord Macaulay.

575 Wandsworth Road, London · Modest, early 19th-century terraced house turned into a work of art by Khadambi Asalache, a Kenyan-born poet, novelist, philosopher of mathematics and British civil servant. His book collection was acquired with the house and reflects his interests in poetry, philosophy and African literature. Although most of the books and magazines were published after 1950, there are some earlier works by European travellers in Africa.

Wightwick Manor, West Midlands · Late Victorian house with Aesthetic Movement-influenced interiors. It contains a large collection of mostly late 19th- and early 20th-century books, including a Kelmscott *Chaucer*. The published outputs of various members of the Mander family are also well represented.

Wimpole Hall, Cambridgeshire · Mansion with rich 18th-century interiors, containing the library of the 1st–5th Earls of Hardwicke after late 19th-century sales. The collection was augmented by books added by the last private owner Elsie Bambridge, including those of her father Rudyard Kipling.

Index

Acknowledgements

The authors are immensely grateful to those who contributed entries to this book: Michelle P. Brown (Professor Emerita, School of Advanced Study, University of London), Dr Juliet Carey (Senior Curator, Waddesdon Manor) and Rachel Jacobs (Curator for Books and Manuscripts, Waddesdon Manor). The authors also gratefully acknowledge the many members of National Trust staff who have made this book possible, including the collections and house teams, curators and conservators who have given help or advice. Thanks are also due to the cataloguers and former libraries curators who have worked on National Trust library collections over the years. We would also like to thank the Royal Oak Foundation and all of the individual donors who contributed to the Country House Libraries campaign.

Sincere thanks to Christopher Tinker, the National Trust's Publisher for Curatorial Content, for commissioning this book and overseeing the editing, design and production; David Boulting, Editor in the Cultural Heritage Publishing team, for his work as project editor; and Gabriella de la Rosa, Lead Editor, Curatorial Content Online, for advice on various entries. We are also grateful to Leah Band, John Hammond, Matthew Hollow, Robert Thrift and Dara McGrath for their beautiful new photography, and to the property teams for supporting photography shoots; Matthew Young for his wonderful cover design; Patricia Burgess for copy-editing the book; Anjali Bulley for proofreading; Christopher Phipps for the index; Susannah Stone for clearing image rights; and Richard Deal at Dexter Premedia for the origination.

A number of individuals outside the Trust must also be recognised here for their generous assistance: Alison Bailey, Caroline Bendix, Professor James Carley, Dr Penelope Cave, Louise Clarke, Eyob Derillo, Dr Francesca Galligan, Peter Kidd, Professor Peter Kornicki, Dr Karen Limper-Herz, Dr Alexandra Loske, Dr Margaret Makepeace, Dr Philippa Marks, Nick McBurney, Dr David Pearson, Professor Nicholas Pickwoad, Edward Potten, Elizabeth Quarmby Lawrence, Dr Suzanne Reynolds and Dr Caroline Shenton.

The National Trust gratefully acknowledges a generous bequest from the late Mr and Mrs Kenneth Levy that has supported the cost of preparing this book through the Trust's Cultural Heritage Publishing programme.

THE AUTHORS

Yvonne Lewis is Assistant National Curator for Libraries at the National Trust. She specialises in library history and architecture, the reading experience, practical book-production techniques and book ownership from the medieval to modern periods, with particular expertise in the 16th to 18th centuries. She has published and lectured on various aspects of library history and provenance and is a council member of the Bibliographical Society.

Tim Pye is National Curator for Libraries at the National Trust. He is interested in all aspects of the history of books, specialising in 18th-century British book ownership and literature. He writes and gives talks on the history of book collecting and has curated major exhibitions on the Gothic and William Shakespeare. He has previously worked at the British Library, Cambridge University Library and Lambeth Palace Library.

Nicola Thwaite is Assistant National Curator for Libraries at the National Trust. She has a particular interest in the cataloguing of rare books and special collections, including provenance research. She was previously Head of Rare Books at Cambridge University Library, where she curated several exhibitions, and has also worked at the Fitzwilliam Museum (Founder's Library) and Modern and Medieval Languages and Linguistics Library, Cambridge.

Picture credits

Page 2 © National Trust Images/Nadia Mackenzie · 4–5, 16, 164, 165 © National Trust Images/Andreas von Einsiedel · 6, 20, 21, 33, 35, 36, 37, 38, 39, 54, 55, 66, 67, 81 (both), 83 (right), 84–5, 94, 95, 101, 108, 109, 117, 125 (both), 130 (both), 131, 146 (both), 149 (both), 150, 166 © National Trust Images/John Hammond · 8–9 © National Trust Images/Paul Highnam · 10, 22 (all), 23, 172 (all), 173 (all), 176 (both), 177 (both), 178, 179 (both) © National Trust Images/David Brunetti · 11 © National Trust Images/ James Dobson · 12, 18 (both), 19, 203 © National Trust Images · 13 © National Portrait Gallery, London · 14 © Norman Parkinson/Iconic Images · 24, 25, 32, 52 (all), 53, 70, 71, 90 (both), 91, 104, 105 (both), 106 (both), 107, 114 (both), 115, 116, 120, 121, 136, 137, 142, 143 (both), 144, 145, 152, 153, 156, 157, 160, 161, 182, 183 (all), 185 (both), 188, 189 (both), 198, 199, 200 © National Trust Images/ Matthew Hollow · 26, 27, 42, 43, 56, 57 (both), 58–9, 60, 61 (both), 62, 63, 64, 64–5, 74, 75, 76, 77 (all), 78 (both), 79, 86 (both), 87 (all), 88–9, 96, 97, 99, 102 (both), 103, 110, 111, 118, 119, 122, 123, 126, 127 (all), 128 (all), 129, 132, 133, 140, 141, 148, 158, 159, 162 (both), 163, 167, 170, 171, 180–1, 184 (both), 186, 187, 192 (both), 193, 204 (both) © National Trust Images/Leah Band · 28, 29 © National Trust/Andrew Fetherston · 30, 31 (both), 98 © National Trust Images/Angelo Hornak · 34 © National Trust/ David Cousins · 40, 41 © Waddesdon Image Library/Mike Fear · 44 © National Trust/Tim Pye · 45 © Antiqua Print Gallery/Alamy Stock Photo · 46, 47, 202 © National Trust · 48, 49 © National Trust Images/Andrew Lawson · 50, 51, 100, 112, 113, 124, 134, 135 (all), 138, 139, 174, 175, 196 © National Trust Images/Robert Thrift · 68, 69, 92 (both), 93 © Waddesdon Image Library · 72, 73 © National Trust/John Pittwood · 80 © National Trust/Laura Kennedy · 82 © National Trust/Rob Auckland · 83 (left) © National Trust/Nicola Thwaite · 151 © National Trust Images/Peter Spooner · 154 (both), 155, 190, 191, 194, 195, 197 © National Trust Images/Dara McGrath · 168, 169 © National Trust Images/David Levenson · 201 (top left) © Estate of Kenneth Rowell; (top right and bottom left) Angus McBean Photograph © Harvard Theatre Collection, Houghton Library, Harvard University; (bottom right) © Estate of Loudon Sainthill; Images (all): National Trust Images/Matthew Hollow · 205 (both) By permission of Llyfrgell Genedlaethol Cymru/National Library of Wales/ Image: National Trust Images/Leah Band

Front cover: top left and top middle © National Trust Images/John Hammond · top right © National Trust Images/Matthew Hollow · middle left and middle right © National Trust Images/David Brunetti · bottom left © National Trust Images/Andreas von Einsiedel · bottom middle © National Trust/Yvonne Lewis · bottom right © National Trust Images/Mark Fiennes · *Back cover:* top left, middle left, bottom middle and bottom right © National Trust Images/Leah Band · top middle, top right and middle right © National Trust Images/Matthew Hollow · bottom left © National Trust Images/Robert Thrift

Published in Great Britain by the National Trust, Heelis,
Kemble Drive, Swindon, Wiltshire SN2 2NA

National Trust Cultural Heritage Publishing

Registered charity no. 205846

ISBN 978-0-70-780464-4

A CIP catalogue record for this book is available from the British Library.

10 9 8 7 6 5 4 3 2 1

Publisher: Christopher Tinker · Project editor: David Boulting
Copy-editor: Patricia Burgess · Proofreader: Anjali Bulley
Indexer: Christopher Phipps · Cover designer: Matthew Young
Page design concept: Peter Dawson, www.gradedesign.com
Additional picture research: Susannah Stone

Colour origination by Dexter Premedia Ltd, London
Printed in Wales by Gomer Press Ltd on FSC-certified paper

Unless otherwise indicated, dimensions are given
in centimetres, height x width

‡ Indicates objects accepted in lieu of inheritance tax
by HM Government and allocated to the National Trust

Discover the wealth of our collections – great art and
treasures to see and enjoy throughout England, Wales
and Northern Ireland. Visit the National Trust website:
www.nationaltrust.org.uk/art-and-collections
and the National Trust Collections website:
www.nationaltrustcollections.org.uk

ALSO AVAILABLE IN THIS SERIES

*125 Treasures from the Collections
of the National Trust*
ISBN 978-0-70-780453-8

*100 Paintings from the Collections
of the National Trust*
ISBN 978-0-70-780460-6

50 Great Trees of the National Trust
ISBN 978-0-70-780461-3

*100 Curiosities & Inventions from the
Collections of the National Trust*
ISBN 978-0-70-780462-0